IMAGES
of America

MONMOUTH BEACH
AND SEA BRIGHT

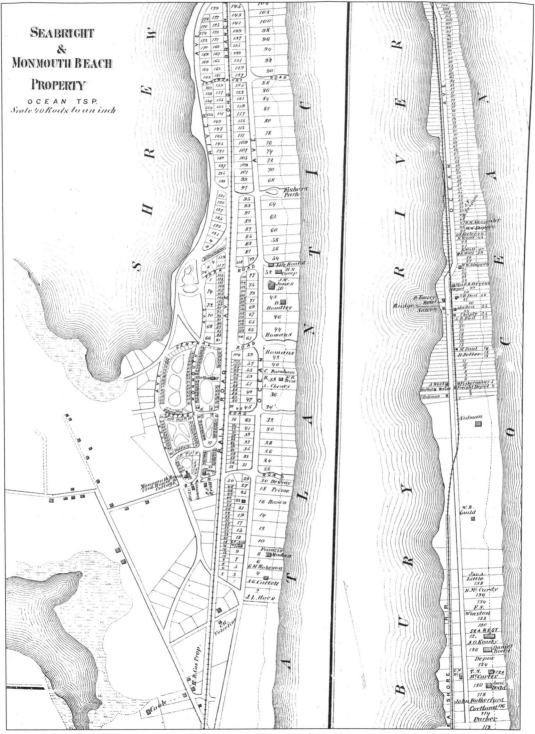

Plate 63 of the 1873 Beers *Atlas of Monmouth County* is based on maps of Highlands Beach and the Forsberg map of Monmouth Beach. Many of the early lot numbers were continued into modern times.

IMAGES
of America

MONMOUTH BEACH
AND SEA BRIGHT

Randall Gabrielan

ARCADIA
PUBLISHING

Published by Arcadia Publishing
Charleston SC, Chicago IL, Portsmouth NH, San Francisco CA

Printed in the United States of America

Library of Congress Catalog Card Number: 2006928677

For all general information contact Arcadia Publishing at:
Telephone 843-853-2070
Fax 843-853-0044
E-mail sales@arcadiapublishing.com
For customer service and orders:
Toll-Free 1-888-313-2665

Visit us on the Internet at http://www.arcadiapublishing.com

This book is dedicated to the Honorable Sidney B. Johnson (see p. 56),
whose long public service, including nearly three decades as mayor,
and love of his hometown earned him recognition as "Mr. Monmouth Beach."
In the golden years of retirement,
he still expresses concern for the future of Monmouth Beach
as he looks fondly back on a lifetime of unmatched devotion to its betterment.

Contents

Acknowledgments

The assistance and cooperation of many helped make this book. The beginnings of the project were facilitated by the liberal access granted to the postcard collections of John Rhody and Michael Steinhorn, longtime supporters of the author. Keith Wells made his collection available in a similar open, generous manner.

The help of several residents was outstanding both for the spirit with which it was offered and the importance of their material. Albert S. and Joan Benoist offered memories of a rich, cultural life in addition to numerous fine images. Artist Gail Gannon has skillfully shown her love of her town and its heritage in her paintings of Monmouth Beach historic subjects. That same concern prompted her offering many fine pictures. Daniel Hennessey was long known not only for his skilled photography, but for his generosity in distributing his work. His wife, Gloria, shares that generosity, for which the author expresses his heartfelt thanks and the regret that Dan did not survive to see publication of a liberal segment of his work. Harold "Boots" Solomon, a distinguished collector, elected to offer his assistance to the author on the occasion of the publication of this book on his hometown. Harold proudly announces that his son Ben and daughter-in-law Rosemary's expected child will begin the fifth generation of Solomons to reside in Sea Bright. Peter Thompson's Poppinga family pictures provide a lengthy diverse look at early-century Sea Bright.

Photography Unlimited by Dorn's continues the regional expansion of its collection of historic photographs. Dorn's Sea Bright images are particularly strong and all are available at their Wallace Street, Red Bank shop. Thanks to Kathy Dorn Severini. Tova Navarra and Margaret Lundrigan offer not only their art, but moral support in a common pursuit. Thanks.

The Honorable James McConville lent his support at a time when his plan of organizing a Monmouth Beach historical society was reaching fruition. His aspirations are worthy and needed as written history has neglected Monmouth Beach. May the new organization's and author's on-going work grow and prosper in concert.

My sincere gratitude and thanks to all lenders, including the Atlantic Highlands Historical Society, Olga Boeckel, Karen and Kevin Bonifide, Michelle and Kevin Collier, Joseph Carney, Elene Dwyer, Alexander Finch, Rosemary Kelly, Evelyn Leavens, the Long Branch Public Library, Mr. and Mrs. Q.A. Shaw McKean Jr., Teri O'Connor, Elizabeth Oakes, Joan Parent, Alice Robinson, Jay W. Ross, Rutgers University Libraries (Special Collections and Archives), Robert S. Schoeffling, Roberta Van Anda, Glenn Vogel, and Robert Zerr.

Introduction

A Common Origin . . . Different Paths

Monmouth Beach and Sea Bright began as a single property, but traveled on different paths to develop distinctive characters, resulting in a history that is a study of contrasts. Both settlements stemmed from a 17th-century land grant to Eliakim Wardell; Wardells Beach was a name prominent on colonial-era maps. Its 19th-century significance is reflected by its inclusion (albeit misspelled) in Thomas Gordon's landmark 1834 *Gazetteer of New Jersey*.

This strip of northern Monmouth County ocean shore was virtually uninhabited through the early 19th century. To the west, the "inland" parts of the future Monmouth Beach had about a dozen houses as late as 1860, as evidenced in Beers' large-scale county map. Henry Wardell's heirs' selling the beach in 1865 to Dr. Arthur V. Conover of Freehold opened the area to settlement. Conover's division of his holdings into northern and southern sectors started a process resulting in the two future boroughs taking separate paths in their developmental journeys.

Mifflin Paul, a railroad executive, purchased the northern part of Wardell's holdings in 1869 with partners Samuel B. Dodd and William W. Shippen. The three men obtained a charter and, in concert with Rumson interests, built the bridge that connected the beach with the Rumson Neck peninsula. Erecting the bridge was a political and business coup. Contrary to some reports, there was no requirement in the partners' deed to accomplish this obstacle-laden task.

Paul and his partners built hotels and summer homes near the bridge. A town developed around the founders; growth in short time spread to the North and South Beach sections adjoining on either side. Sea Bright's early character had a high public profile.

The southern portion of the Conover tract was sold in 1871 to Daniel Dodd, who formed an association that included Edward Q. Keasbey and John Torrey. They hired Harry Forsberg, a Swedish engineer, to survey the land in 1871. His map, which included the southern portion of what would become Sea Bright as part of Monmouth Beach, divided Monmouth Beach into numbered lots delineated by curved streets intersections. The community's lot numbers are still referenced in deeds; the map was adapted and published in the 1873 Beers *Atlas of Monmouth County* (p. 2). Key inner group land investors included George F. Baker (p. 34) and Edward A. Walton.

Monmouth Beach developed a character of privacy and exclusivity. Residential, social, and recreational life centered around the association's clubhouse or inn and a cluster of houses (regrettably underrepresented in this volume) encircling the inn. The as-yet-unincorporated Monmouth Beach was identified closely with the association; indeed, some considered the association's territory as "Monmouth Beach proper." Uncovering the linkages among investors, the association, inn, and country club, a task beyond the scope of this work, will provide better

understanding of the inner workings of early Monmouth Beach.

Many houses, often large, elaborate, and costly, were built on the ocean shore of both Sea Bright and Monmouth Beach. They ranged from North Beach (p. 87) to the southern stem of Ocean Avenue in Monmouth Beach (p. 9), the only surviving private house residential strip. The houses have disappeared through a succession of storms, fires, demolitions, and preservation-motivated moves. Some of the destruction is recounted herein pictorially, while at least one removal has been described in a contemporary account (p. 93, top). However, unsubstantiated stories of house movings have long been one of the shore's thorniest historic sidelights. Extensive illustrations of former shorefront housing suggest the perils of exposure to the ocean, a condition reinforced by the on-going regular loss of sand.

New plans for land use have reshaped the landscapes of both towns, notably with multiple dwelling complexes, and in Sea Bright, additional beach clubs. Space limitations and a focus on older history omitted most of these later projects. However, the significance of high rises to Monmouth Beach justified the inclusion of the three there.

The presence in Sea Bright of a downtown characterized by a long and extensive commercial presence and narrow side streets provides a major distinction from Monmouth Beach, where a handful of business buildings have emerged on residential Beach Road. Indeed, the newest of them, the Monmouth Beach Apothecary, occupies a former dwelling.

The presence of alcohol in public life provides a study in contrasts, too. Monmouth Beach is characterized by the rarity of its licensed establishments, while Sea Bright has many. Their bars reflect changed patterns of life in the second half of the 20th century. Mid-century saw few taverns in Sea Bright, with one of the earliest and most picturesque, the Swedish Hop (p. 122), having roots with Sea Bright's historical origins.

Political life continues the contrasts. Issues in Sea Bright are often aired in an open, vocal, vigorous manner, while Monmouth Beach public life traditionally has mirrored its clubish organizational roots.

The entire coast shares a maritime past, one transformed from commercial fishing to pleasure boating, both of which are illustrated as space permitted.

The visitor traveling Ocean Avenue would neither spot nor feel the borough boundary were it not for the presence of border signs. A common origin, although traveled along different paths, have both boroughs sharing a beautiful, although fragile, adjacent place on part of America's most appealing landscape, the New Jersey shore. The necessary linking of the two towns in one book produced some frustration, as space was limited and both places have rich pictorial assets. Fine images had to be left out, providing a springboard for a possible second volume. Ommisions usually result from the lack of space or pictures. The author hopes the success of this book will justify a second and seeks the loan of additional material, especially images strong in human interest. He may be contacted at 71 Fish Hawk Drive, Middletown, NJ 07748, or by calling (732) 671-2645.

One

Monmouth Beach

Ocean and River Shores

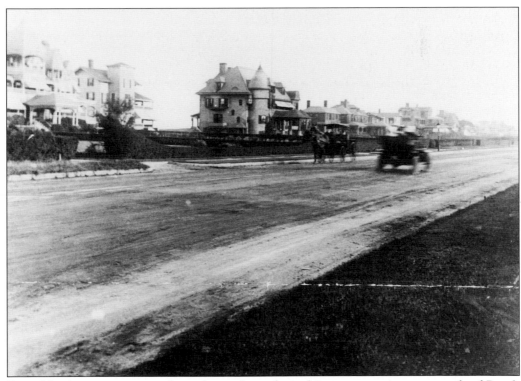

Riverdale Avenue was once the only north-south road in town, veering east north of Beach Road to proceed near the shore. The Monmouth Beach Company improved Ocean Avenue following the relocation of the railroad westward from its original shore location, permitting the construction of a wide thoroughfare suitable for the oceanfront houses built from the 1870s through the end of the century. This c. 1905 image was taken looking south.

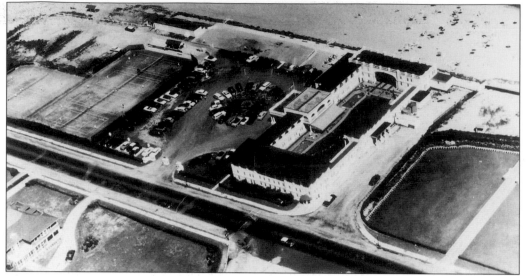

The Monmouth Beach Bath and Tennis Club, on the shore opposite Beach Road, was reportedly built in 1912. One suspects it should date a few years earlier from a developmental standpoint. However, its varied Revival architectural elements and historic map evidence place it several years into the 20th century. The club is built around four pavilions. Two have hipped roofs and two are flat. This aerial view is from the mid-1950s.

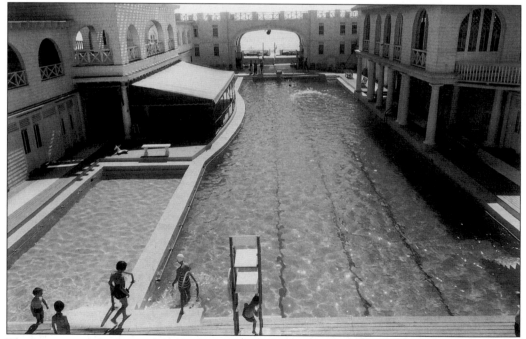

The interior pool courts of the bath and tennis club were decorated with Tuscan columns to create an ambiance of Roman baths. The organizational history of the club is yet to be revealed. It fell into a state of disrepair and borough ownership for tax default. The borough deeded the property to the Monmouth Beach Club in 1949 for $50,000 with a proviso that improvements be made, that the place be returned to the tax rolls, and with a reverter clause in the event its several covenants were violated. This image was taken c. 1950. (The Dorn's Collection.)

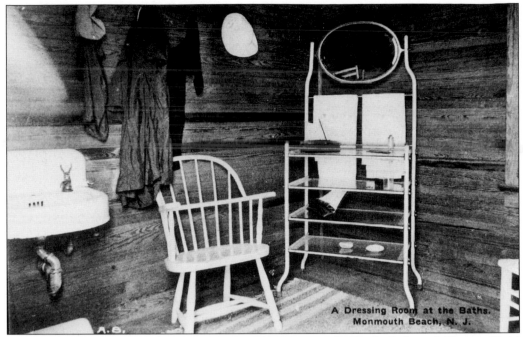

A Dressing Room at the Baths.
Monmouth Beach, N. J.

How appealing were the dressing rooms at the Monmouth Beach Bath and Tennis Club? Apparently they were considerably so, or why place one on a postcard? (*c.* 1915.) The club thought so, advertising in 1919, "Commodious and Exceptionally Attractive Dressing Rooms." However, a user recently recalled them as "just terrible . . . boxes, all in a row." Perhaps their appeal depends on expectations and when the opinion was being offered. (Collection of Michael Steinhorn.)

Ocean Avenue. MONMOUTH BEACH, N. J.

The southern stem of Ocean Avenue is seen looking north on a *c.* 1915 postcard. The bath and tennis club is in the distance.

The Green Inn (built c. 1881) and its cottages and bungalows are pictured c. 1905 in a Galilee Company advertisement. The smaller buildings and suites in the main house were rented for the season. Meals were offered on a weekly plan, while an aquarium kept seafood alive for the ultimate in freshness. The place was the Miramar Inn when it was destroyed by fire in 1914; five occupants had to be rescued from a balcony.

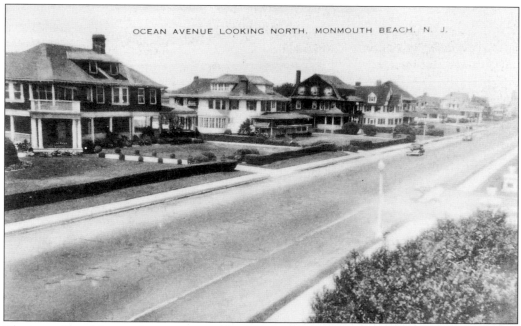

The west side of Ocean Avenue, viewed looking north from the upper level of the Monmouth Beach Bath and Tennis Club in a 1940s postcard, remains intact and little changed today. The house on the corner of Beach Road, left, has had its second-story porch enclosed.

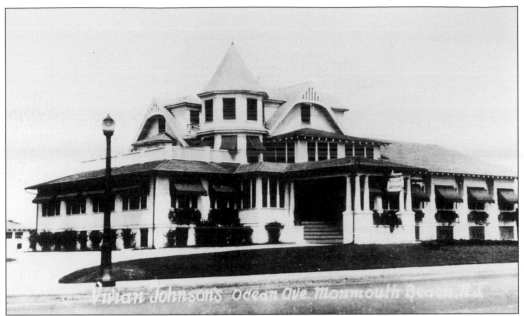

Vivian Johnson operated a nightclub in a former Queen Style residence on the shore side of Ocean Avenue, north of the Monmouth Beach Bath and Tennis Club. The enclosed porch, wing at right, and porte cochere appear to be modifications for club use. The place was destroyed by fire in 1935.

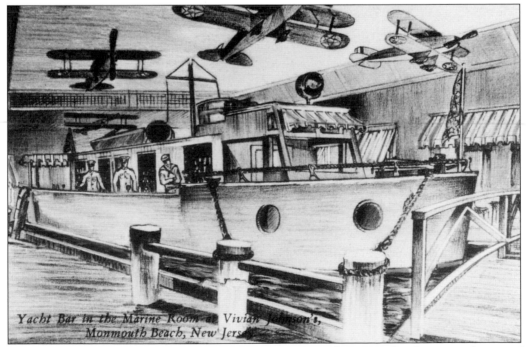

The Yacht Bar in Vivian Johnson's nightclub embraced popular nautical and aviation themes of the times. This is an early 1930s postcard. (Collection of John Rhody.)

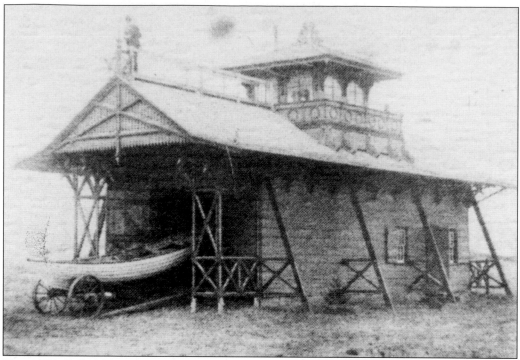

Henry Wardell sold a plot on the shore to the United States government in 1849 for the establishment of Life Saving Station Number 4. This image was taken c. 1870s.

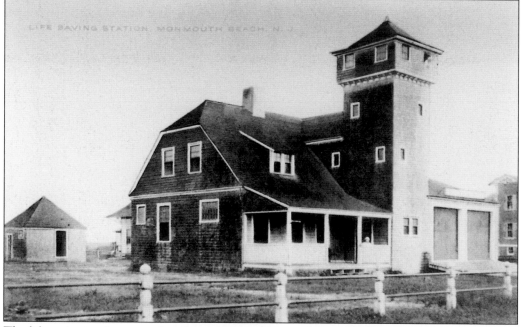

The life saving station moved to the west side of Ocean Avenue, and was housed in this Shingle Style building with a square lookout tower around the turn of the century. The building, later a Coast Guard station, stands vacant at the time of publication with plans for restoration and the establishment of a shipwreck museum. This postcard was created c. 1910.

Sunday evening services in the parlor of the Monmouth Beach Club House, the building later known as the Inn, constituted early worship in Monmouth Beach. This attractive Shingle Style edifice was built in 1881 and dedicated that July. It is the second St. Peter's of Galilee Protestant Episcopal Church, an earlier church having been built in 1873. The first church was attributed to the efforts of Mrs. F.H. Teese, Mrs. David Dodd, and Mrs. A.Q. Keasbey; the pictured church was known historically as the Rikers' church. It was in use in summers only and was served by visiting clergy. This image is from William J. Leonard's 1903 *Seaside Souvenir*.

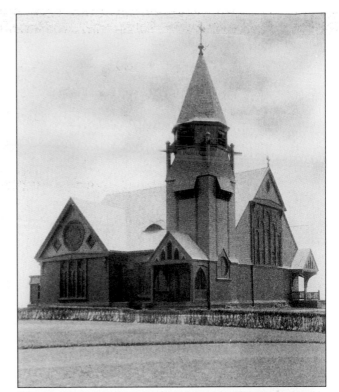

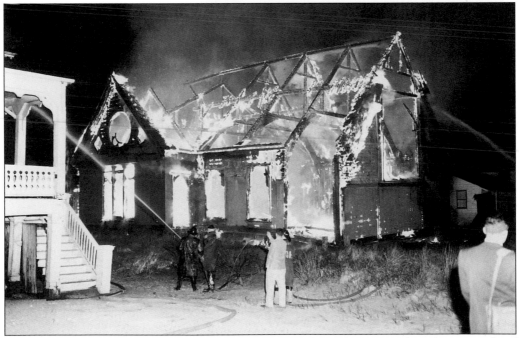

St. Peter's had been unused as a church since 1941 and was later moved to the west side of Ocean Avenue. An application to use it as a theater was denied c. 1949, while its tower was apparently removed at an unspecified date. St. Peter's was destroyed by fire on Sunday, May 1, 1955. (The Dorn's Collection.)

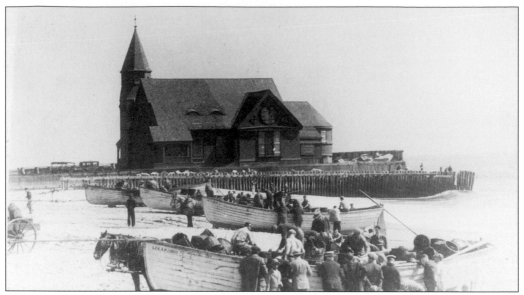

The curiosity-seekers seem as numerous as the fishermen in this undated early-20th-century view at Galilee. The *Leila K* was owned by Fred Cook and named for his wife. Capt. Nelson Lockwood told writer Carlysle Ellis in 1917 the origin of the name of the area, claiming it stemmed from a pious, bible-reading fisherman who was regularly led to the verse, "Now as he walked by the Sea of Galilee, his brother, casting a net into the sea; for they were fishers." He painted Galilee on a board that he hung on his house. The story is charming, be it fact or folklore. Note the fish baskets, desirable antiques today.

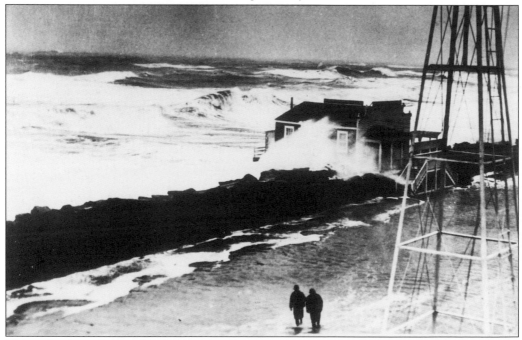

Nelson Lockwood owned a shorefront plot in Galilee south of the Coast Guard station from c. 1870s. The Lockwood Sea Food store, origin unknown, stood on the rocks until washed away in a storm c. 1956. A replacement was later built on the west side of Ocean Avenue.

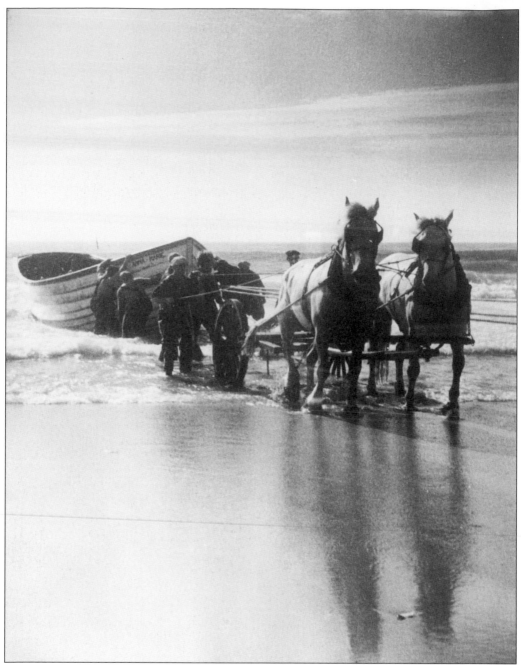

Fishermen had fished from the Galilee shore for many years. Sensing coming change with the sale of Wardells Beach, many of them banded together to buy a $500 plot from Arthur V. Conover in 1870, transferring the title in 1884 to the corporation named the Galilee Fishing Association. Their pound boat was a typical Sea Bright skiff enlarged to about 50 by 10 feet. The square-sterned, lap-streaked, seaworthy, capacious open boat typically required a crew of six and a team of horses to land on the beach. This image of the *Ann Marie* was photographed by George V. Maney, who won a prize in a *Herald Tribune* Amateur Photographers Contest *c.* 1940. The boat was owned by Sam Sicilliano.

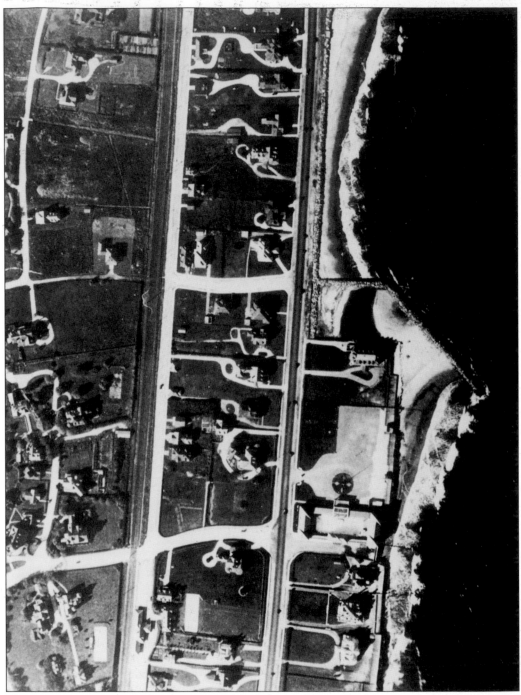

The square structure on the shore is readily recognizable as the Monmouth Beach Bath and Tennis Club. The four houses adjacent on the south were demolished to construct the Shores and Admiralty high-rise condominiums (p. 51). The ground that once supported shorefront houses north of the club (p. 68) is now eroded. Beach Road is the cross street bisecting the picture, while Cottage Road appears to stop at the railroad. Note the station south of Beach Road. The image is, perhaps, c. 1940s.

Louise Benoist's robust physique reflects a strong athleticism that led her to compete in basketball, among other sports. The elder daughter of Andre and Alice, she was born in 1903 and is seen c. early 1920s. Her independent nature made her one of "the original flappers." She married twice. In later years, her interest in basketball gave way to tennis and bridge. She died in the early 1990s.

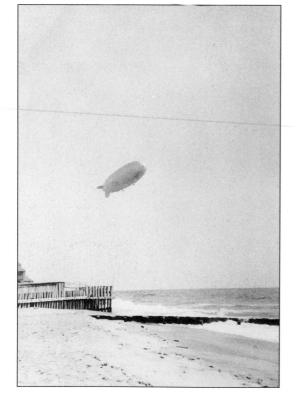

The Zepplins' size and grandeur, combined with the novelty of trans-Atlantic flight, made watching airships a popular pastime of the late 1920s and 1930s. Their loudness, audible well before their appearance overhead, gave shutterbugs an opportunity to locate a camera for a photographic souvenir. This 1930s image in front of a house on the southern stem of Ocean Avenue is believed to be of the *Hindenberg*, which burned on landing at Lakehurst, New Jersey, on May 6, 1937.

19

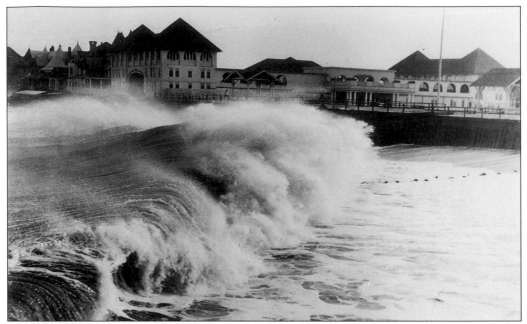

This dramatic, undated, perhaps 1940s, photograph of waves crashing north of the Monmouth Beach Bath and Tennis Club suggests the on-going problem of shore protection. Costly beach replenishment programs see their newly deposited sand wash away, at times rapidly. As the book nears completion in February 1998, a storm well-contained by the sea wall has again claimed a piece of the beach, leaving observers wondering how, when, and at what cost are effective solutions found.

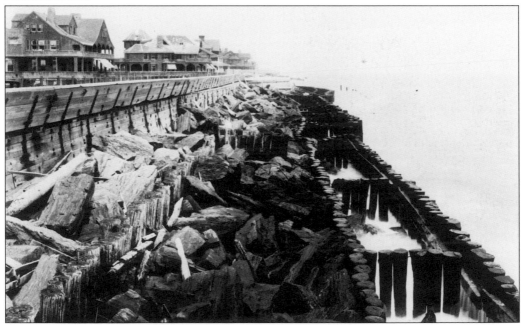

Decades of news reports included numerous items of individual property owners building and having destroyed their bulkheads. This September 1925 image shows the inadequacy—even futility—of small-scale storm protection measures.

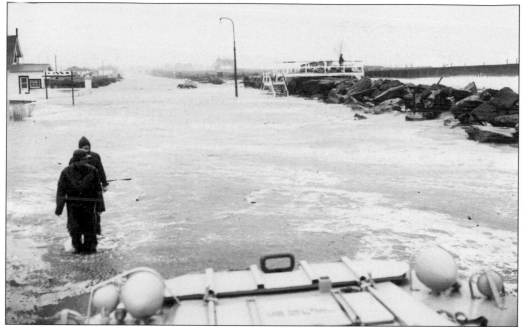

A glimpse of flooding in the midst of Hurricane Carol on Ocean Avenue on August 31, 1954, points out the inadequacy of the then-existing sea wall. Greater destruction was visited upon the boardwalks at Long Branch and Asbury Park, while a power company lineman was electrocuted in Neptune.

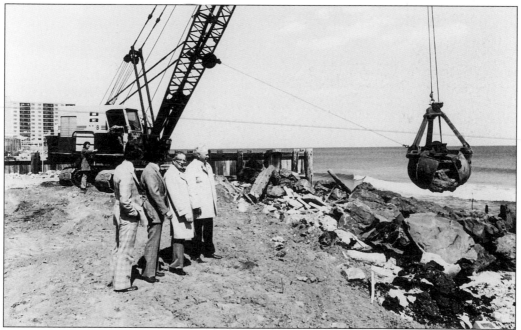

Construction of a 920-foot south beach sea wall from the borough's bathing pavilion to the border at Long Branch began on April 7, 1977, aided by a $1 million Public Works Employment Act grant. The three men from left are identified. They are federal employees John H. Mruz and Ron Breslow, and Mayor Sidney B. Johnson.

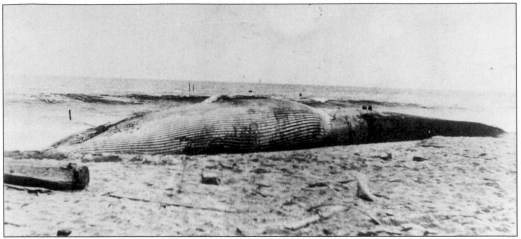

This beached whale was photographed at Galilee in August 1907. No details were found other than the size of the mammal recorded on the photographic postcard: 52 feet long and 8 feet high. (Collection of John Rhody.)

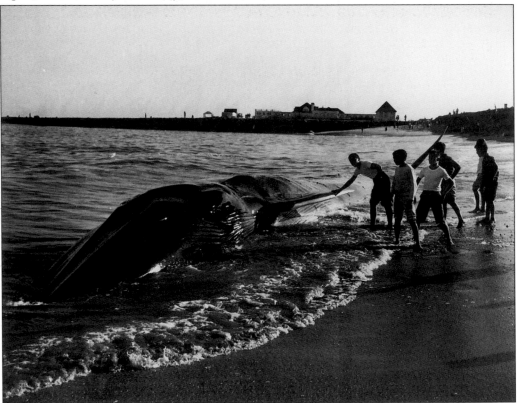

A reported 3,000 people gathered on Friday, September 29, 1961, to view this 60-foot, approximately 50-ton finback whale that washed up in front of 80 Ocean Avenue, severely injured by a ship's propellers. A Coast Guard cutter took the whale to the vicinity of Texas Tower 4, where it had to be destroyed. Beached whales were not frequent at Monmouth Beach. The beached whale incident prior to this one was recalled by Police Chief George V. Maney as a December 1949 appearance of a mere 20-footer.

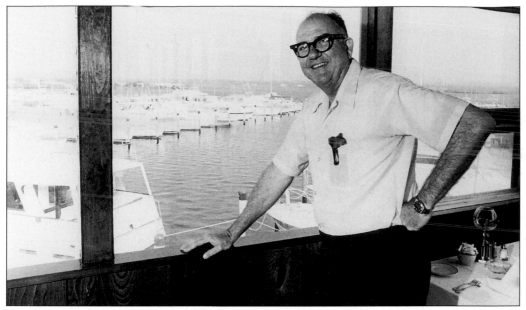

Walter Mihm, the son of former Mayor G. Henry Mihm, joined the latter's marine business, which began c. 1946 as a rowboat rental operation, and presided over much of its greatest growth. The widely known Mihm name has been associated with marinas, yacht sales, construction, and maritime operations. Walter Mihm also built the Channel Club and Channel Club Tower. He is a former chief of the Monmouth Beach Fire Company and long provided gratis food supply for their annual fair. Mihm is seen in his office in 1972. (The Dorn's Collection.)

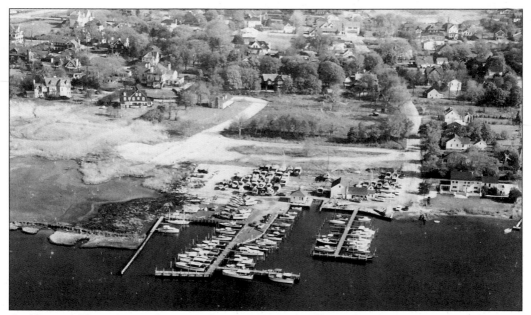

G. Henry Mihm, mayor from 1945 to 1949, was influential in securing a state-financed dredging project to deepen Monmouth Beach Cove. This preceded a major expansion of the Mihm Marina operations, seen here in 1960. The scene is not recognizable today because of expansions that have taken place over the years. (The Dorn's Collection.)

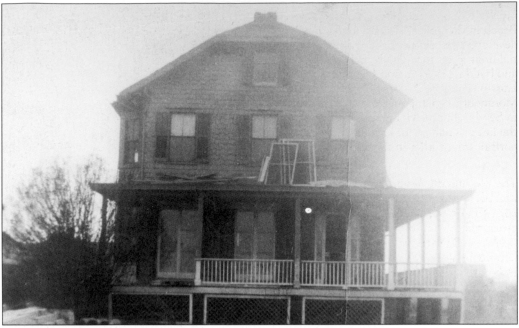

Jay W. Ross acquired the Joseph West house at 46 West Street *c.* 1933, and this picture was taken at the same time. The house was being renovated, and Jay put in a plywood ceiling (early personal building experience served him well while buying and selling many Monmouth Beach properties). He occupied other houses at times, but now lives here in an environment reflecting his love of classical music in general and organ music in particular; the house contains some powerful organs. The photograph below reflects the house's current appearance.

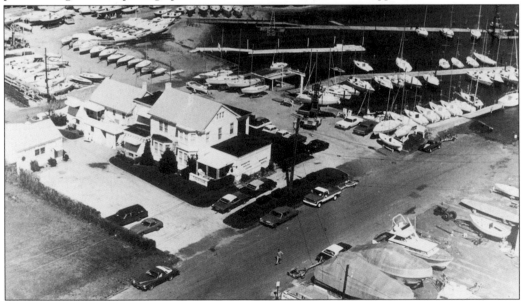

Jay W. Ross's place at 46 West Street was modified to include an office to oversee the marina and yacht businesses he unexpectedly started in 1962. The cove had been dredged and the location was ideal, as suggested by activity around him. Ross, who probably does not know the meaning of "retirement," presides over the business in his ninth decade.

Jay W. Ross, a Brooklyn native, visited Monmouth Beach in the mid-1920s and settled c. 1931. He developed his real estate acumen through family holdings, prior to a lengthy career investing and building in Monmouth Beach. Ross is best known for his public benefactions, including the Monmouth Beach police building and libraries in Sea Bright and Monmouth Beach. A wing in the latter is named for him. Jay is seen in a Dorn's portrait from earlier in the 1990s.

The Monmouth Beach First Aid Squad sponsored its 11th annual skating races on Sunday, January 24, 1970, on the Shrewsbury River. Awards were presented by President Charles Schultz (rear, at right); co-chairman Walter Burns is second from left. Some of the winners are Lori Cancalosi, Deborah Schultz, and Susan Barkalow (third, fourth, and fifth from left in the front row of small children); Carol Pastureus is at left in the middle row, while Susan Collara and Margie Johnson are fifth and sixth in the middle row, both with long dark hair on their shoulders to lessen doubt to which row number four belongs.

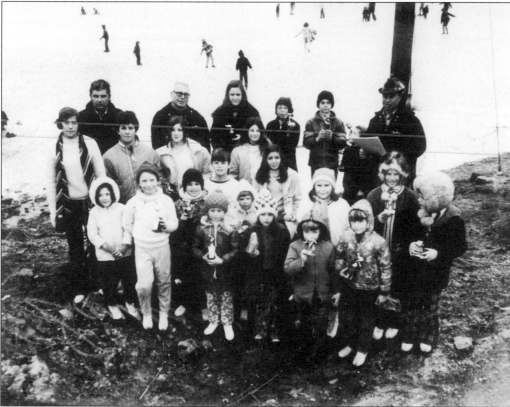

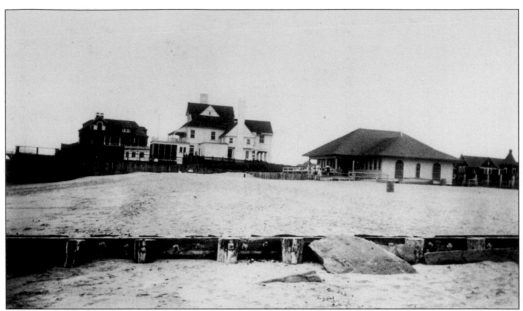

The borough bought shore property in 1919 for establishment of a public beach. This bathing pavilion, likely built not long thereafter, stood on the site until destroyed in the storm of 1962. The date of this photograph is unknown.

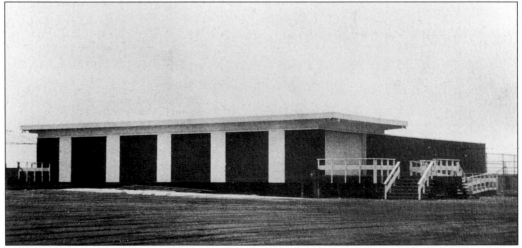

The replacement bathing pavilion was designed by Albert S. Benoist and built as a one-story structure. The second story was added later, creating a current appearance quite unlike this 1960s image.

Two

Monmouth Beach
Places to Live

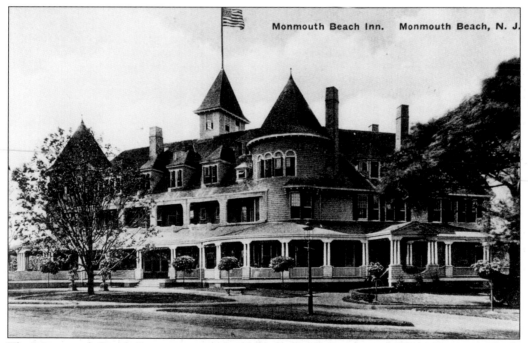

The Monmouth Beach Inn, occupying the block on Beach Road west of River Street, was built around the old Wardell house. The Monmouth Beach Association also built a circle of summer homes around a court, with inn and cottage life linked in an exclusive club atmosphere. All rooms faced outside; most had private baths. The inn had the present bath and tennis club facility as part of its operation. The inn was destroyed by fire in December 1929. A private residence is on the site now. (Collection of Michael Steinhorn.)

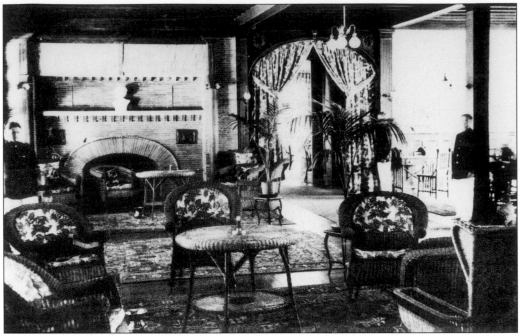

The inn claimed to be more like a manor house than a hotel. Its foyer, pictured above, was large and airy, extending across the building from east to west. The dining hall was a spacious room, with a southwestern exposure to assure cool air during meal hours. Both views on this page are taken from *c*. 1915 postcards. (Collection of Michael Steinhorn.)

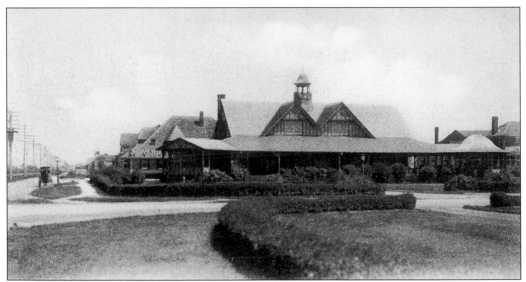

In 1896, the Monmouth Beach Country Club built this Shingle Style clubhouse and a bicycle building (designed by Romeyn and Stever of New York and erected by Robert H. Hughes of Long Branch) on the northeast corner of Beach Road and Railroad Avenue. The building is associated with its adjoining tennis courts and social events held inside its spacious, open interior with a stage at one end. The clubhouse was sold to the borough *c*. 1917 and relocated to Beach Road and Willow Avenue for municipal use. This image is a 1906 postcard.

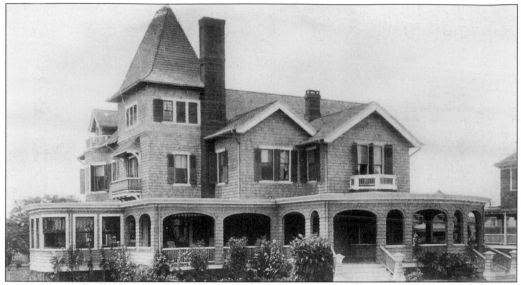

The Edward A. Walton Shingle Style house was located on the southern stem of the west side of Ocean Avenue, built in the 1870s on lot number 11. It is seen in a *c.* 1900 image from W.J. Leonard's *Seaside Souvenir*.

The tower of the George M. Robeson house, which appeared from first glance at this late-19th-century image to have been of later construction, was described in the August 4, 1873 *New York Times* as Robeson's addition to what had been a plain chalet, a place where he wrote, but would not admit visitors. The house may have been built by Daniel Dodd, as Robeson, a secretary of the navy in the Grant administration, did not take the title until 1874. The house, built on lot 6 at the foot of the east side of Ocean Avenue, no longer stands.

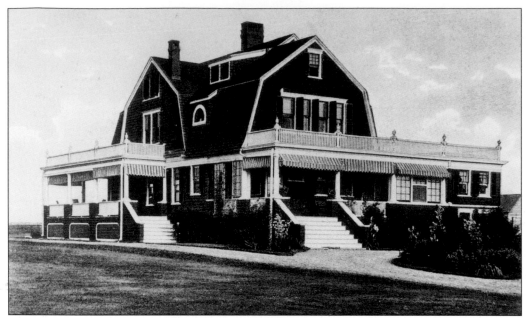

The Louis James house suggests the coming of the Colonial Revival and is distinguished by its intersecting gambrel-roofed gables. The image is a from a c. 1910 postcard. (Collection of Michael Steinhorn.)

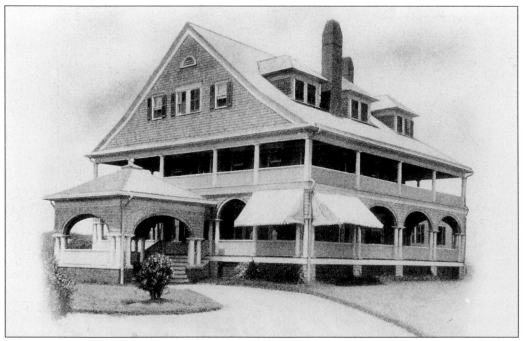

The open porches of Samuel Riker Jr.'s Ocean Avenue house maximized exposure to sea breezes. This is a c. 1900 image from W.J. Leonard's *Seaside Souvenir*.

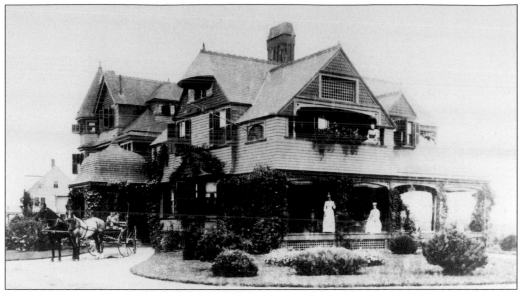

Two houses were moved and joined near Railroad Avenue and Central Road, perhaps in the late 1920s, when Albert Trageser owned them. The property was bought by Jay Ross in 1947, but was owned by the Exeter Construction Company in 1965 when, according to a news account, the place was leveled in a controlled burning. The Hamiltonian Apartments, now the Wharfside Condominiums, are on the site now.

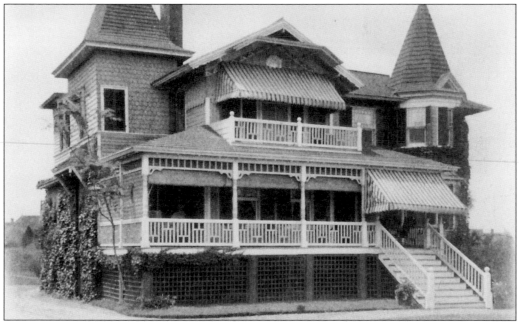

The W.R. Potts house, built around the early 1880s, embraces a number of design elements, reflecting either its construction at the time of changing architectural fashion or alteration. The center gable of the main block appears to have originated in the Stick Style popular in early Monmouth Beach. The towers, reflecting late-19th-century Queen Anne influence, may have been added. The location was the west side of Ocean Avenue, south of Beach Road. This is a *c.* 1900 image from W.J. Leonard's *Seaside Souvenir*.

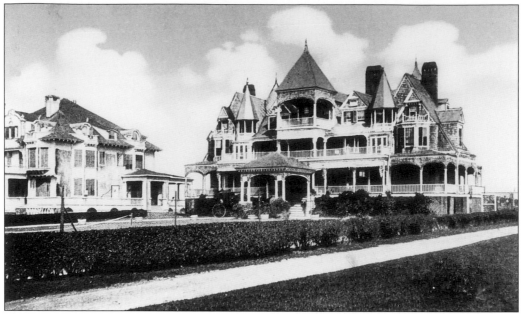

The Ocean Avenue Humphrey cottage was a fine example of Queen Anne style, with an extravagance of turrets, porches, and irregular surfaces. It was built *c.* 1880 on the east side of Ocean Avenue. This postcard image was made *c.* 1910.

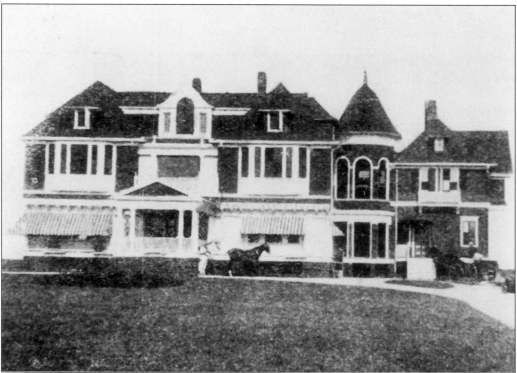

A.B. Proal's Ocean Avenue house is a fine example of the Shingle Style, built *c.* 1880s. The house was expanded in 1893, and that is when the tower and probably the wing on the right were added.

The origin of this house on the east side of Ocean Avenue near the site of today's Shores condominiums is unknown. L.W. Baldwin was its owner at the time this *c.* 1910 postcard was published. The house is possibly *c.* 1880s, with the porches later additions. (Collection of John Rhody.)

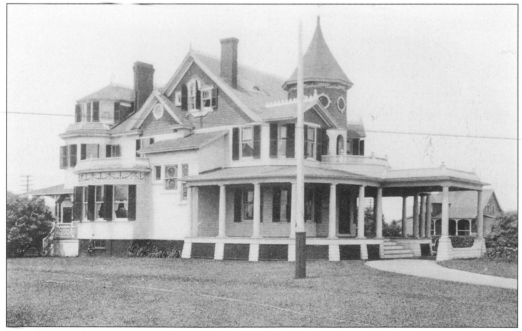

Benjamin Van Brunt's Ocean Avenue house may have originated as a modest Shingle Style that was expanded over time. He appears to have been a local builder and was known to have made an addition on the east side of his house in 1890. This *c.* 1900 image is from W.J. Leonard's *Seaside Souvenir*.

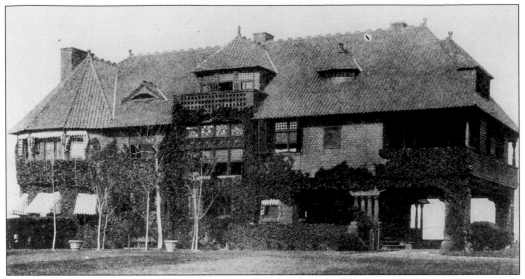

Country houses made up a major part of the oeuvre of New York architect Bruce Price (1843–1903). He had two major commissions on Rumson Road in Rumson, but his numerous designs at the restricted community of Tuxedo Park, New York, comprise his best-known domestic work. This Shingle Style design for George F. Baker was built in the mid-1880s. Baker was a major real estate investor in Monmouth Beach; many of his holdings appear in the 1889 *Wolverton Atlas*, while his name surfaces regularly in title searches. This image is from the June 17, 1899 edition of the *Mail & Express Illustrated Saturday Magazine*.

George Fisher Baker, born in 1840 and having received a home and private school education, became a clerk in the New York state banking department in 1856. A co-founder of the First National Bank of New York, Baker became its second president in 1877, having raised his stature by sound action during the panic of 1873. Baker amassed a fortune estimated at $200 million at its peak, making liberal gifts in his later years. He was a director of many corporations, 81 at one time, and became chairman of his bank in 1909. Baker was pre-deceased by his wife Florence in 1913, dying himself on May 2, 1931. (From *King's Notable New Yorkers*.)

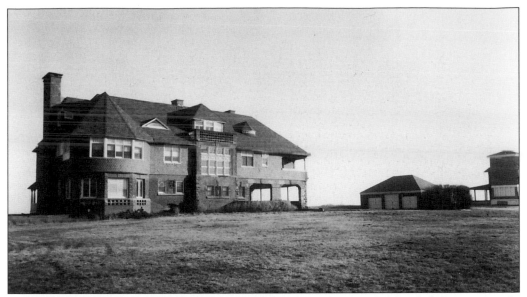

The house's stone was red, while Frank Hawk III, an architect who lived there as a youth, indicated the wood was stained red. The Baker house was named Sea Verge. Its stature on completion is reflected by the publication of a gelatin print in the Imperial Edition of the April 3, 1886 *American Architect and Building News*. This image from December 1960, not long before its demolition, indicates little change. (The Dorn's Collection.)

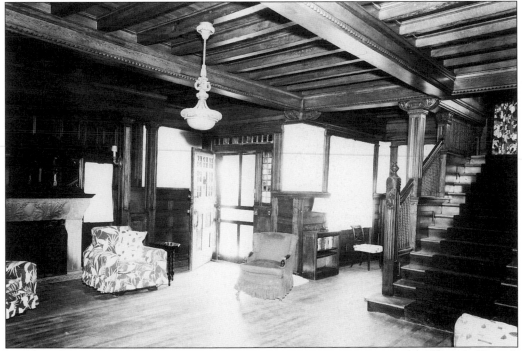

Richly carved staircases are often hallmarks of Bruce Price interiors. The Baker hall's rich paneling, also seen in a 1960 image, is consistent with Price's contemporary Rumson examples and was an outstanding architectural feature. The Shores condominiums are on the site now. (The Dorn's Collection.)

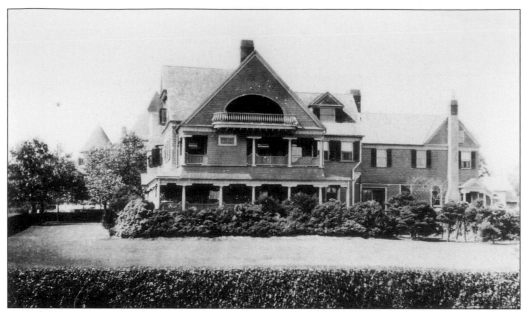

Frederick S. Douglas of Newark built this fine Queen Anne-Shingle Style house, designed by Allen L. Hartwell, a Long Branch architect, at 13 Beach Road in 1890. The main entrance is on the Club Circle west corner; this undated early-20th-century view shows the third-floor open balcony on the east elevation facing the ocean. The well-preserved, little-changed house was sold by Mrs. Douglas in 1926 following Frederick's death.

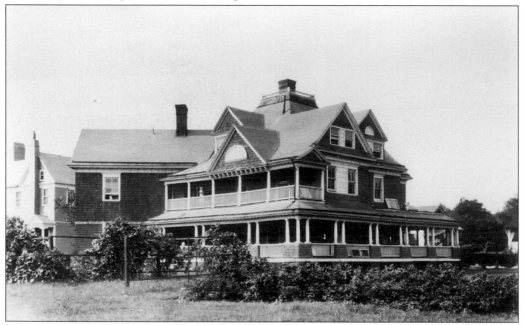

This Shingle Style house formerly stood adjacent to the one pictured at top, on a Club Circle lot. It was likely built by Mary Herter, who owned multiple Monmouth Beach houses, and it may be the one designed and erected for her in 1882 by Charles A. Zimmerman. Expansive porch space reflects the early desire for open-air exposure near the shore, but, alas, in modern times the lot became more attractive for the contemporary houses now on the site.

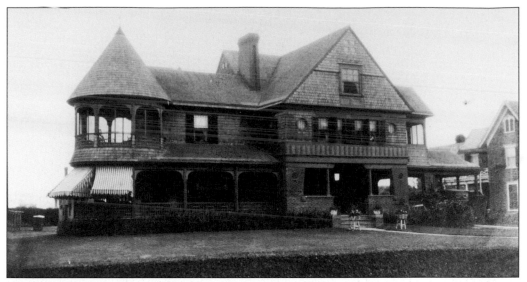

The Bowles Colgate house at 12 Beach Road was likely built in the mid-1880s, but the architect and other details of its origin are unknown. The fine, well preserved Queen Anne-Shingle Style house is distinguished by its two round towers on the east facade. This image, undated but perhaps early 20th century, also depicts its paneled band between the first and second floors on the north elevation facing Beach Road, two round windows above it, and a porte cochere in the northwest corner.

Bowles Colgate was a third-generation family member of the soap and perfumery manufacturer then known as Colgate and Company, joining after completing his education and succeeding his father Charles at its head upon the latter's death. Colgate was known for his philanthropy, notably for Methodist causes. He lived in New York and also had a home in Lakewood, New Jersey, where he died in 1902 at age 56. (From *King's Notable New Yorkers*.)

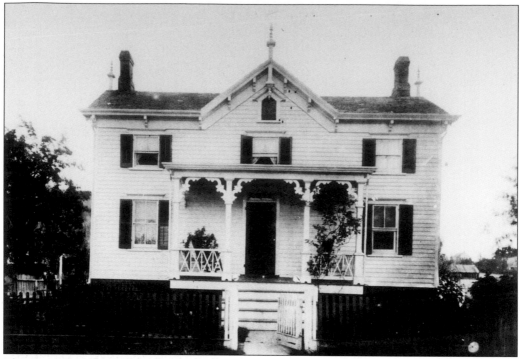

The c. 1860 John Maney house is one of the few remaining houses from before the 1870s development period. The vernacular house appears to stand at 2 Wesley Street, with noticeable changes to its former decorative finishings.

This undated image, perhaps from the late 19th century, is reported to feature a Cook farmhouse that disappeared by unknown means some while ago. It may have been located near today's borough hall, which is placed on former Cook property.

The Dean family is pictured *c*. 1900 in front of their still-standing house at 22 Wesley Street.

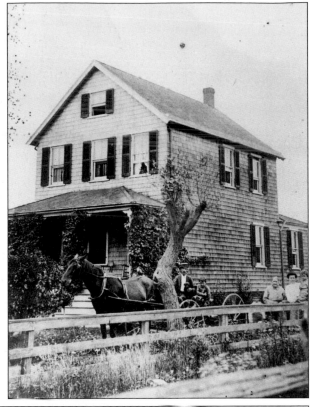

This Vernacular Victorian house probably dates from the 1890s. It was the home of the John Maney family. He was a painter and is said to have lived in the garage at right following marital differences. The place at 68 Riverdale Avenue is little changed, but is clad with shingles and has an enclosed porch.

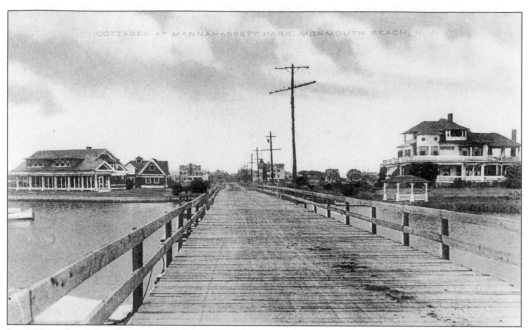

In 1894, the Manahasset Park Association surveyed a tract around Valentine Street that crossed Manahasset Bay and was partially in Long Branch. This view, looking toward Monmouth Beach, was taken from the bridge at the end of Valentine that was demolished c. 1962. It was published on a c. 1910 postcard. The building is a later-day Monmouth Beach Inn.

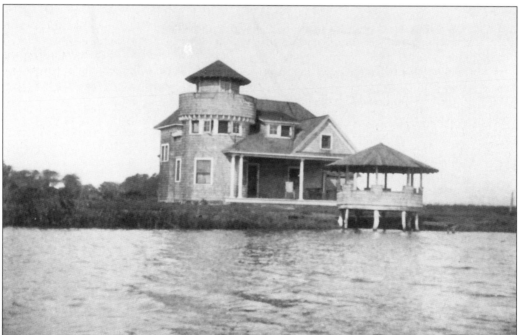

House lots comprised most of Manahasset Park. There was limited pre-World War I construction and much of the neighborhood was not constructed until after World War II. Bungalow Number 2 appears here on a c. 1905 postcard.

Andre Benoist was born in 1880 in Paris, studied at the Conservatoire with some of France's most famed musicians, graduated in his teens, and emigrated to the United States. He chose to become an accompanist early in his career, working with numerous star soloists. Benoist gained acclaim on the 1910 American tour of Luisa Tetrazzini, receiving an invitation to work with the young violinist Albert Spalding at Monmouth Beach. Alice, his second wife, is pictured here c. 1910. Benoist is pictured at his first Monmouth Beach home, located at 24 Valentine Street, a rental from the dramatic actor Oliver Byron, who built it with his own hands as a recreational pursuit. The small but well-designed Shingle Style house was described by Benoist as looking "very much like an English manor viewed through the wrong side of opera glasses. It was all beams, gables and rough hewn walls." The little-changed house still supports the gambrelled gable with the tree-trunk posts visible in this c. 1915 photograph.

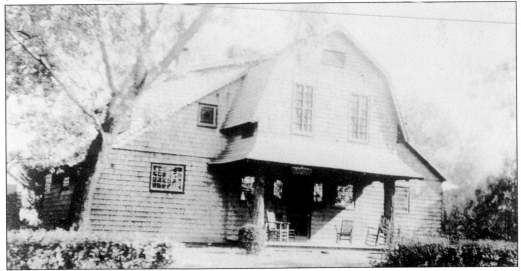

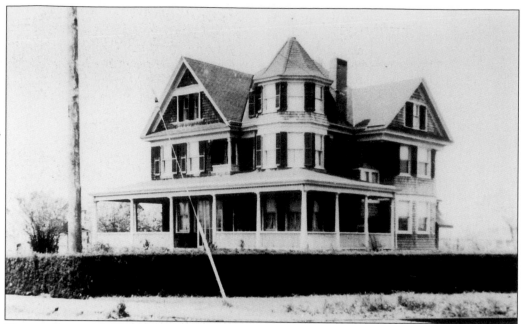

The southeast tower is the dominant architectural element of 15 Valentine Street, a house designed by George E. Ferguson and built in 1899 for Jesse Manahan. It was bought by Andre Benoist in 1919 and is now owned by his son Albert.

Albert Benoist is pictured with his first dog, Sandy, found by his father beached on a piece of driftwood. The dog objected to the long separations required by the family's travels. Sensing trip preparations, the dog placed himself on the nearby railroad tracks in front of an oncoming train, refusing to get out of the way, engaging in what Albert knows was an act of self-destruction.

Albert Benoist, left, is seen at 15 Valentine Street with friend George "Winkie" Delacorte and his sister Marguerite. Winkie started *Ballyhoo* magazine, his springboard into the family business, Dell Publishing.

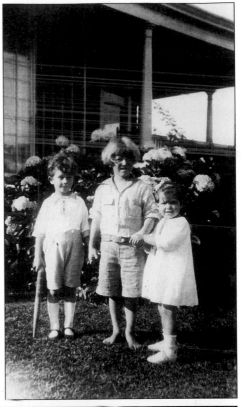

Andre Benoist, one of this century's leading piano accompanists, is seen c. 1920 with Albert Spalding, one of this country's most famed violinists and with whom Benoist is most often associated, in a publicity photograph.

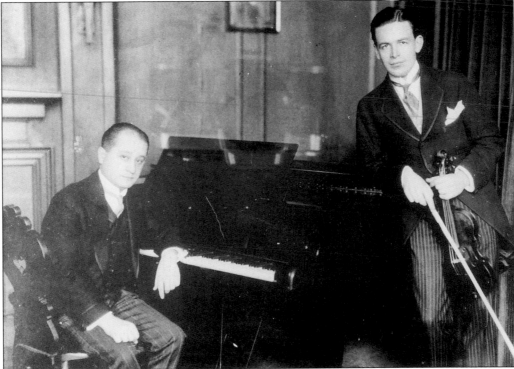

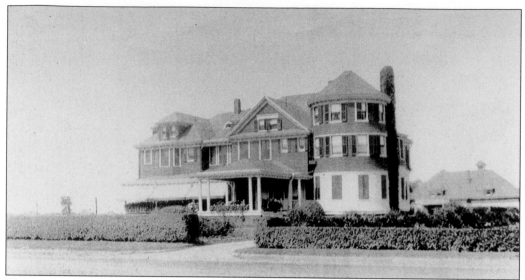

The Shingle Style J.W. Spalding house on the west side of Ocean Avenue is pictured prior to remodeling.

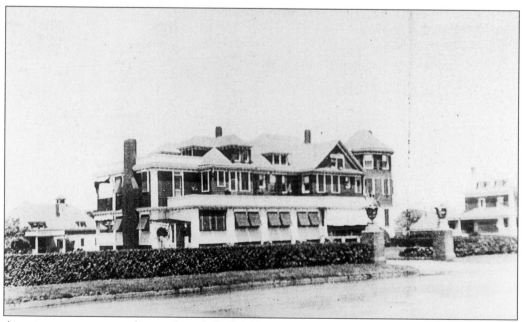

A major expansion on the south and the building of a room around the front porch were two modifications to the often-changed Spalding house. Three private houses are on the site now.

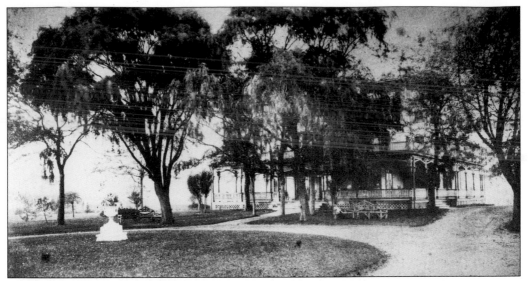

Hugh J. Hastings, a New York newspaper publisher and political figure, bought 33 acres in Monmouth Beach in 1873 for $75,000. The *New York Times* wrote a satirical account on June 30, 1873, calling his place "Gotobed Farm" (which sounds facetious), indicating it contained a "fine old ancestral" mansion known as "Bourbon House" and a group of aged animals. The satirical vein of the article marks it as less than totally reliable, but the place was once the home of ex-Sheriff Jordan Wooley. Hastings died in 1883 from injuries received in a carriage accident in Long Branch.

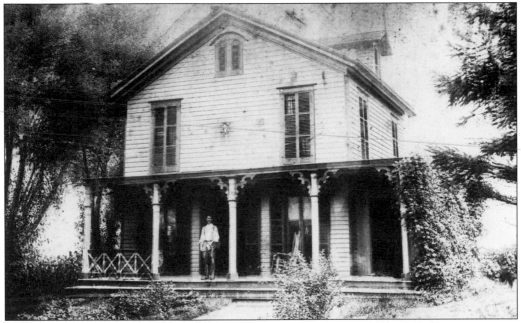

Mr. Hastings's caretaker's house is pictured with an unidentified figure late in the 19th century. After the death of Hugh Hastings's widow Mary in 1896, the property was sold to George F. Baker and Edward A. Walton. The main house was used for a golf clubhouse. The property was conveyed to George W. Gale as trustee in 1911; he in turn sold the Hastings acreage to the Monmouth Beach Land Company in 1912.

The Hastings estate entrance is said to have been in the vicinity of Hastings Place. No pictorial or physical evidence of a golf course has been found. The property was mapped for the Shorelands development in 1912. Shorelands sold its first lot that November to Anne R. Tull.

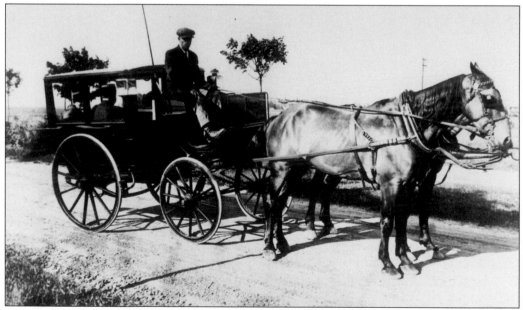

This real estate carriage met potential customers at the railroad station for viewing Shorelands property c. 1913. Shorelands placed a number of covenants in their early deeds that were to run until 1935. These covenants banned houses over two stories, mandated architectural reviews, and set up the developer's right to use a three-foot strip in the rear of each piece of property for utilities.

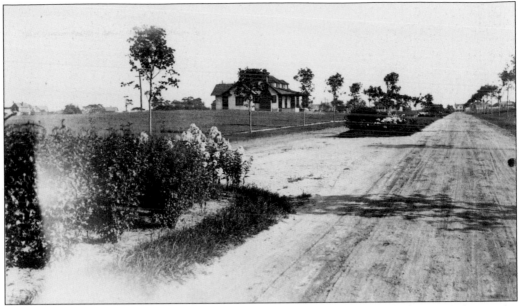

Monmouth Parkway, Shorelands' broadest thoroughfare, is seen looking north in the 1920s. Few houses were built in the early decades; most Shorelands construction followed World War II.

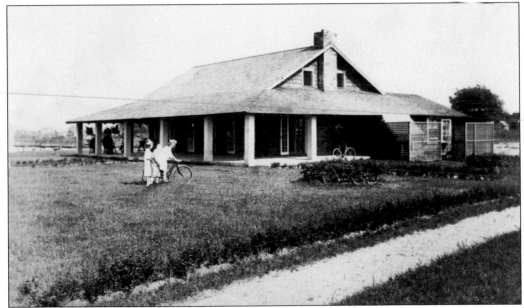

The Shorelands Association acquired at least two plots from the Monmouth Beach Land Company, including a park near lot 97 and a Monmouth Parkway tract near lot 164. The Shorelands clubhouse at the foot of Shrewsbury Drive was destroyed by fire in 1961. A second clubhouse on the river was also destroyed.

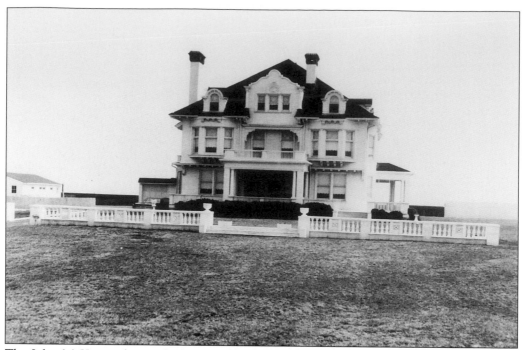

The John McKesson house, built *c.* 1960s, is shown here prior to being demolished for the Admiralty condominium, *c.* 1970s. A partial older view is on the top of p. 32. This image probably reflects turn-of-the-century colonial revival remodelling.

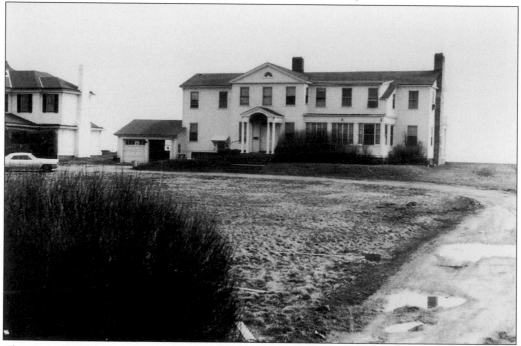

This is a *c.* 1970 image of a house taken down for construction of the Shores condominium. The lack of remaining physical evidence did not encourage research of early, apparently much-altered houses removed in this period.

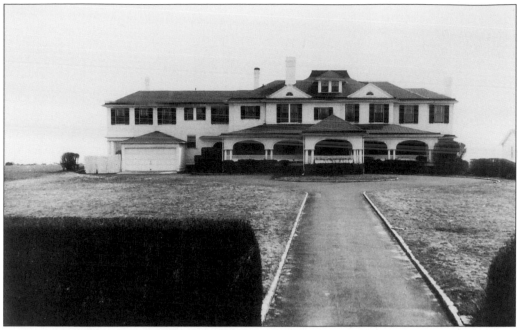

This house on the site of the Admiralty was reported moved *c.* 1970.

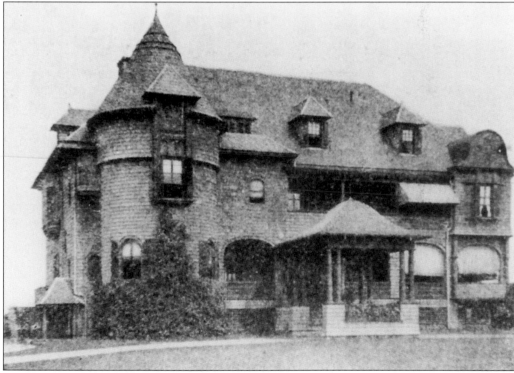

William Barbour's fine Shingle Style house was designed by H. Edwards Ficken of New York and built by James Rudolph of New York in 1886. The house was demolished *c.* 1970 for construction of The Shores. This image is from the June 17, 1899 *Mail & Express Illustrated Saturday Magazine.*

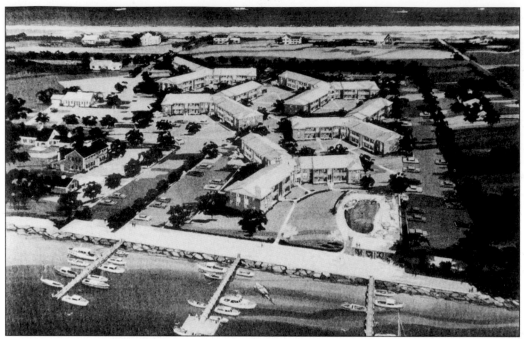

A fully developed Wharfside apartment complex is seen in this rendering from architect Albert S. Benoist. The availability of Shrewsbury River marshland and an unexpected source for mortgage funds provided a 1961 stimulant for a town that had not been growing. Benoist's design innovation planned the buildings in the shape of a "Y." Three were built initially; the project expanded to five buildings. Benoist notes that the Central Road project, now the Hamiltonian, provided a spur for further development, preceding decades of multiple dwelling growth in Monmouth Beach.

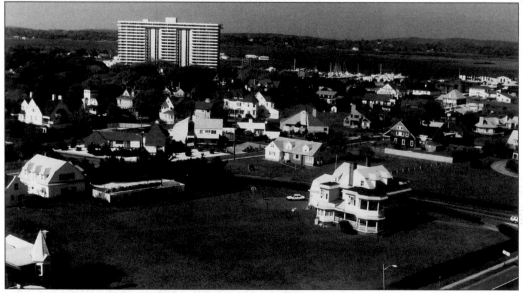

Channel Club Tower is viewed in a contemporary image looking northwest from the shore. The 17-story condominium—completed in 1973 as a joint venture of Walter Mihm and American Standard, Inc.—was the first of Monmouth Beach's high-rises.

Condominium construction was seen as a stimulant for growth and as a potential means of tax relief in the early 1970s. Eager investors and lenders developed several projects of both high-rise and townhouse variety. Two of the largest and most notorious were on the southern stem of Ocean Avenue. The first was The Shores (top), two 12-story buildings begun in 1972; they were completed but occupied slowly, encountering recession-related problems. The developer of Seacoast Towers (middle), a single 14-story building begun in 1973, became bankrupt in 1974, after the steelwork was nearing completion. The structure was known as "the skeleton," as it stood incomplete and idle for over five years. New developers resumed work in 1980, completing in 1982 a building with a new name, the Admiralty (bottom). Stabilized tax rates in the period seemed to confirm the projections of the early condominium advocates. Former mayor Sidney Johnson believes Monmouth Beach would be "unaffordable" without them.

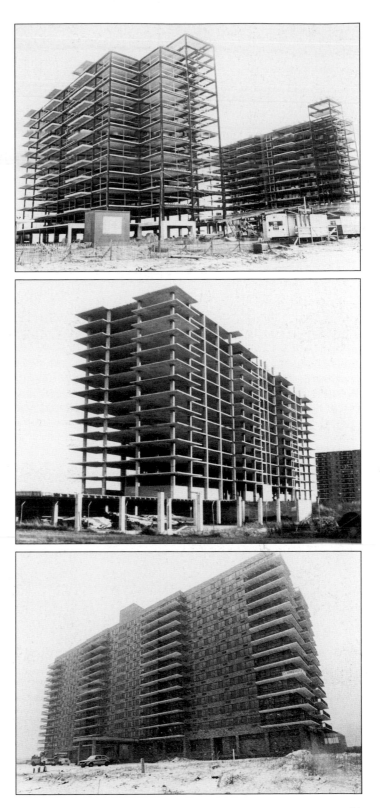

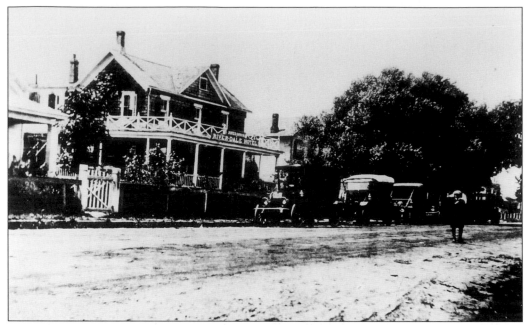

The Riverdale Hotel was a rooming house at 64 Riverdale Avenue that was operated at one time by Pop Hanifin. It is now a private residence, showing no signs of its hospitality past. The building is still recognizable from this c. 1920 image, but bay windows reflect expansion of the front second story, and the upstairs porch balusters have been relocated to the first.

This Manahasset Park waterfront house became a later-day Monmouth Beach Inn after being converted to a bar and rooming house. It no longer stands.

Three

Monmouth Beach

Organizations

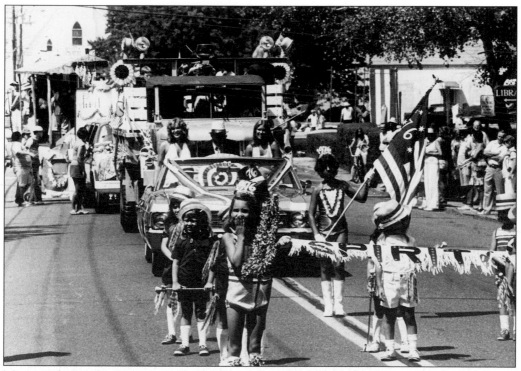

Monmouth Beach's bicentennial parade on Saturday, July 24, 1976, attracted around 400 participants, beginning at borough hall and proceeding on a circuitous route to the Griffin Street ball fields. Later events that day included athletic contests, a Beach Road block party, fireworks, and dancing. We'll presume the yawning young marcher was not bored, but, perhaps, had been up late partying. Cynthia "Cindy" Sokol was selected queen of the parade. Mayor Sidney Johnson is in the center of the automobile, while Cindy's ladies-in-waiting, her sister Nina and Leslie Kulthau, are seated to the left and right respectively.

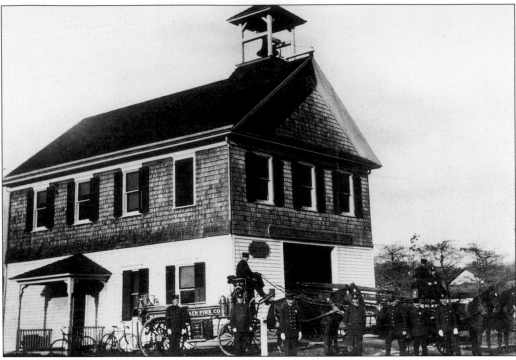

Monmouth Beach, which had received the fire-fighting services of the Oliver Byron Engine Company of Long Branch, formed its fire company in 1905, pre-dating the establishment of the borough. Nelson Lockwood Sr. was elected first president and a lot at Beach Road and Borden Street was bought from Isaiah West for a firehouse. The first apparatus was this horse-drawn wagon built by John E. Eyles of Sea Bright. The 34-inch bell alarm was purchased from Sears, Roebuck & Co. This image is c. 1910.

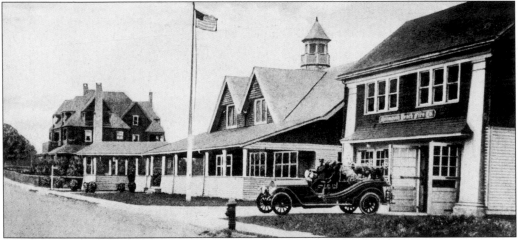

In 1917, the borough purchased two lots on the south side of Beach Road from the estate of Jemima Cook. The casino was relocated (p. 28) and converted to a municipal hall and offices. A lot was transferred to the fire company c. 1919. The firehouse, which, when built in 1906 by Abraham Francis, had its entrance at the gabled end as depicted at top, was moved across the street and new doors were built on the side. This c. 1925 image is looking east on Beach Road. (Collection of John Rhody.)

The borough hall and firehouse have had additions built on their south, or back ends. This *c.* 1960 postcard depicts the former with a new cupola and the latter with modern doors. The front of the borough hall, a large, open room, the pride of Monmouth Beach, and one of the finest interiors on the shore, is used for a variety of municipal and recreational functions. The scene is little changed today, although the hall is clad with vinyl siding and the pilasters are removed from the firehouse.

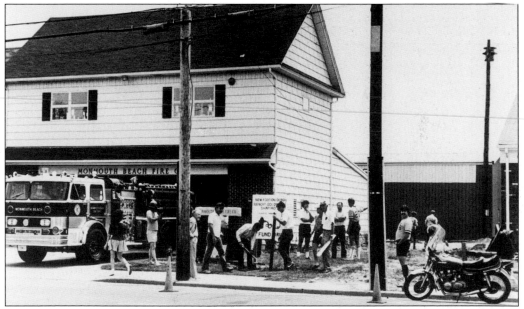

The Monmouth Beach firehouse was also expanded on its west side *c.* 1980. The extension was designed by Albert S. Benoist. The architect, ever-mindful of structural support, is seen near the left, apparently holding up the telephone pole. The truck is a 1974 Hahn, noteworthy as the first in the area to have a 3.5-inch hose, which possessed substantial water-carrying capacity.

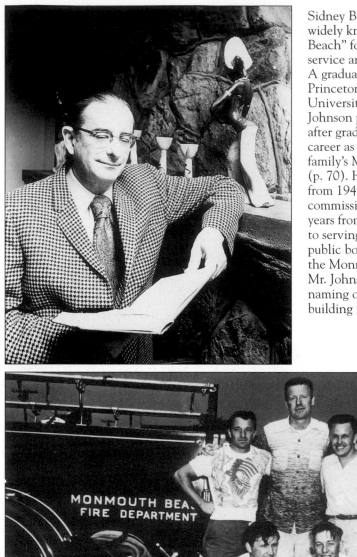

Sidney B. Johnson, born in 1915, is widely known as "Mr. Monmouth Beach" for his many years' public service and his love of the community. A graduate of Lawrenceville (1933), Princeton (1937), and Columbia University Law School (1940), Johnson practiced law for 10 years after graduation prior to a business career as owner and operator of his family's Monmouth Cold Storage Co. (p. 70). He was mayor for 29 years from 1949 to 1978 and borough commissioner for an additional eight years from 1989 to 1997, in addition to serving as a member of several public bodies. A founding trustee of the Monmouth Beach Library in 1968, Mr. Johnson was recognized by the naming of the borough's 1990 library building in his honor.

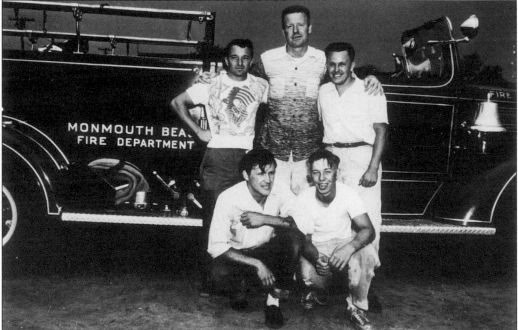

The borough celebrated its 50th anniversary on July 4, 1956. Firemen Lawrence De Marco (left) and Charles E. Schultz, both of whom would later serve as company chief, are kneeling. James R. Maney, a former chief, is standing between two unidentified men. The truck is a 1948 Type 45, 500-gallons-per-minute Mack Triple Combination Pumper, purchased by the company with financial aid from the borough.

Teachers posing in front of borough hall provide a glimpse of Monmouth Beach's World War II service memorial. They are, from left, Mrs. Johnson, Mrs. Van Note, and Miss Kittell.

The four-room Monmouth Beach Elementary School, an attractive Georgian Revival design by Philadelphia architect Clyde S. Adams, was a modern facility when built in 1909 at the northeast corner of Griffin and Hastings Streets. It eliminated the necessity of borough children traveling to a Long Branch school. Although expanded twice, the building was inadequate and beyond cost-effective rehabilitation when demolished in April 1982 for replacement by the present school.

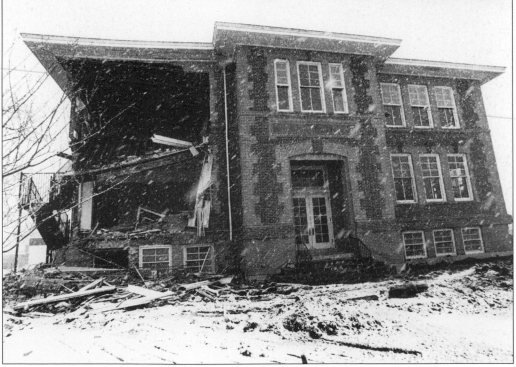

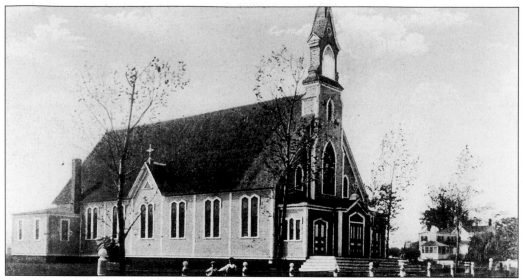

The Roman Catholic Church of the Precious Blood originated as a mission of Star of the Sea of Long Branch, which purchased for $1,500 a Riverdale Avenue lot from John Maney in 1889. This Victorian Gothic church was designed by Jeremiah O'Rourke, New Jersey's leading Catholic church architect of his time. The cornerstone was laid on June 21, 1891, prior to the awarding of the contract to John Burke of Asbury Park; he built the church in 1891–92. A few changes have been effected to this church building since the c. 1910 image was made. The upper tower has been removed, vinyl siding has been applied, the stairs are changed, and three ventilators rise from the section of the roof visible in this picture.

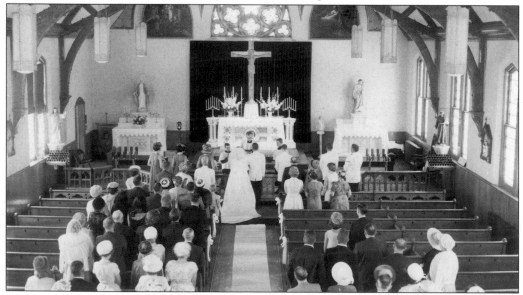

The interior of the Church of the Precious Blood has changed in several ways since this August 1964 wedding. The altar has been moved forward, the tabernacle placed in a corner, and the rails removed. The statue of St. Joseph, pictured at right, has joined Mary on the left, and the side altars were removed. The round paintings are gone, eight hanging light fixtures were replaced by six new ones, and additional lighting was installed. The sanctuary retains the charm of an old country church.

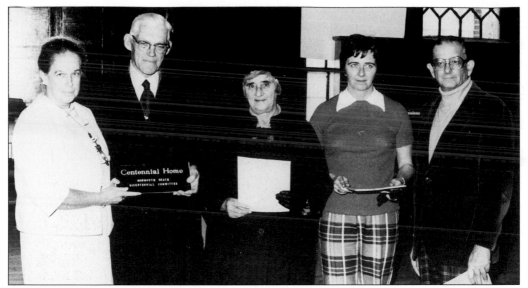

Monmouth Beach's commemoration of the bicentennial included the formation of a Centennial Homes Committee that certified the century-old stature of 21 houses. Homeowners were presented with wall-mountable plaques to reflect this distinction. Priscilla Brower, left, is presenting a plaque to William and Mrs. Bradley, while committee member Rosemary O'Brien and Mayor Sidney Johnson look on. In the intervening 22 years, quite a few more century homes have been "made."

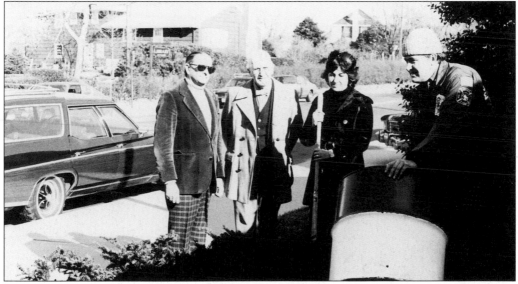

Monmouth Beach's bicentennial celebration wound down, literally, with a steel drum time capsule with mementos from 1976 being buried in front of borough hall for residents of 2026. A planned granite marker was not erected, so perhaps this caption will help serve as a reminder. What's inside? The contents include photographs of local groups, license plates, a bicentennial flag, a church bulletin, and a 500-page book with residents' messages to posterity. The 50-year recovery span was chosen so some present at the burial will be around for its retrieval. From left are Sidney Johnson, mayor; Samuel Smith, historian and chairman of the bicentennial committee; and committee members Betty Heath and her husband, Michael.

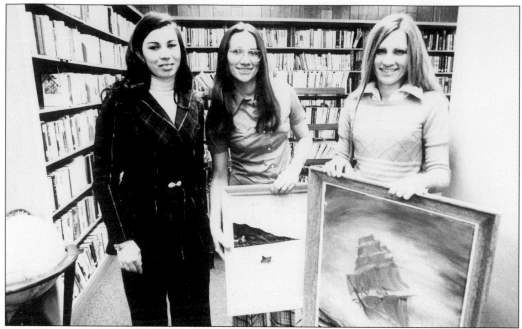

The Monmouth Beach Library is now located at 18 Willow Avenue in a building designed by Albert S. Benoist. It was erected in 1968 and expanded on the south with the Jay W. Ross wing *c.* 1988. The library has long been the site of art exhibitions; this one dates from January 1976 and took place in the old library.

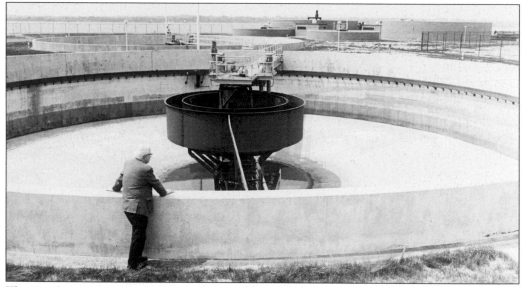

The Northeast Monmouth County Regional Sewerage Authority opened its sewage treatment plant on a 10-acre plot at the foot of Highland Avenue in the Raccoon Island section in July 1971, following extensive consideration of proposed sites and member communities. Pictured prior to opening is a clarifier, or settling tank. The member towns are Monmouth Beach, Oceanport, the Borough of Shrewsbury, West Long Branch, Fair Haven, and Little Silver; customer communities include half of Tinton Falls, Red Bank, Shrewsbury Township, Rumson, Eatontown, and Sea Bright, plus Fort Monmouth. Their grounds include recreational facilities.

Four

Monmouth Beach
Around Town

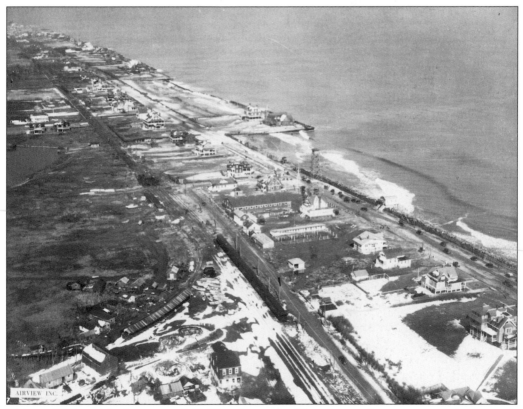

This *c.* 1927 aerial view around Galilee shows the lifesaving station at center; the tower is surrounded by various elements no longer in existence. Note Lockwood's shop on the rocks (p. 16). At right are fishermen's huts, their rail siding, and several boats in winter storage. St. Peter's Church and the Riker house appear vulnerable at top center, as the beach to their south has eroded. Waterfront houses still lined Sea Bright's shore at top left. The black line in the center appears to be five railroad cars on a lay-up siding.

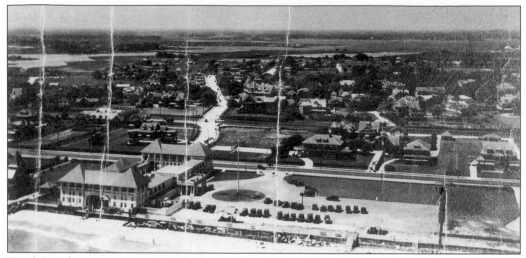

Beach Road running west, the light line in the middle of this 1920s aerial, provides a perspective for places pictured elsewhere. The Monmouth Beach Bath and Tennis Club in the foreground is seen on p. 10, while the Church of the Precious Blood, p. 58, is at the west end of the street. The Bowles Colgate and John Torrey houses, opposite one-another at the tops of pp. 36 and 37, can be spotted above on Beach Road by their tower and east gable respectively. Behind the latter is the Monmouth Beach Inn (p. 27). The Shrewsbury River is the body of water in the rear.

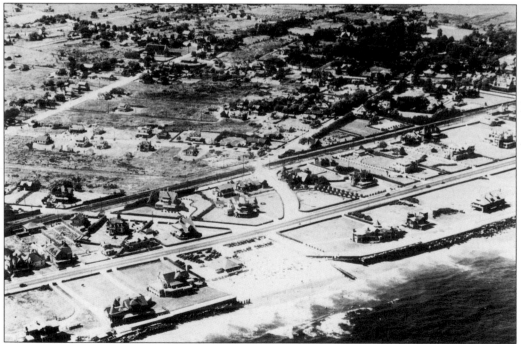

The public beach is at the center of this c. 1930 aerial, with the pictured and replacement pavilions shown on p. 26. The two houses to the right of it still stand, south of the strip cleared (not visible here) for the high-rise condominiums. The curved street in the center is Surf Road. River Avenue forms the "V" with Ocean Avenue at left. This image is the Aerial Explorations, Inc. photograph; a postcard version exists.

This view is apparently southeast Monmouth Beach viewed from the Beach Road area.

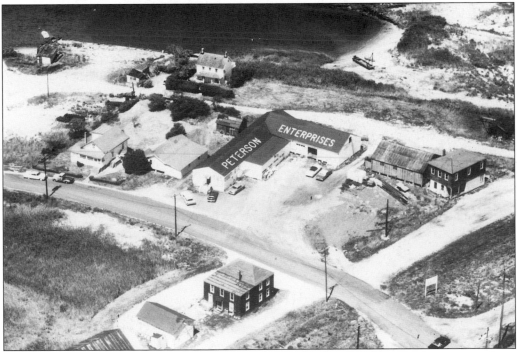

Peterson's wholesale fish business was founded *c.* 1950 on Park Road, which curves in front near the Shrewsbury River. This aerial was taken for an E.O. Peterson's calendar in the 1950s, with the roof sign etched in the negative for that purpose. The site was cleared in 1997 for the construction of about 12 houses.

This c. 1940s view from 13 Beach Road shows the houses on Seaview Avenue, then Railroad Avenue.

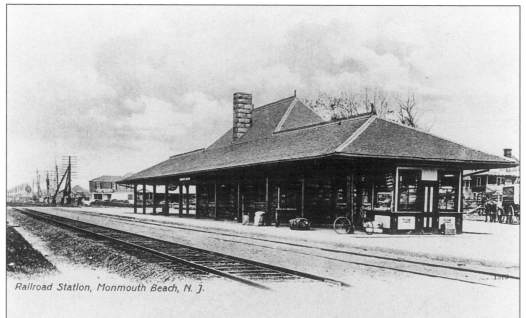

Railroad Station, Monmouth Beach, N. J.

This Monmouth Beach railroad station was located about 100 feet south of Beach Road on Seaview Avenue, formerly Railroad Avenue, having replaced an earlier station c. 1890s. The attractive design was highly regarded; the elaborate station was built with the influence of George F. Baker (p. 34), an official of the New York and Long Branch Railroad. Service on the shoreline ceased in 1947; the station was later removed. This image represents a c. 1910 postcard.

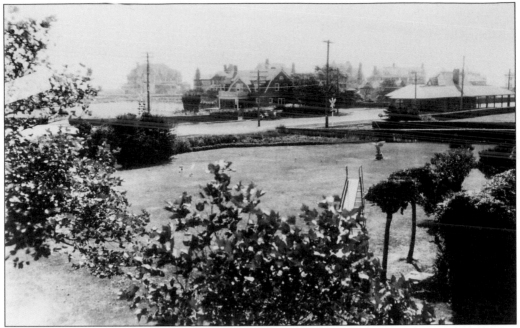

The proximity of the Monmouth Beach station to Beach Road is shown in this *c.* 1940 photograph taken from the grounds of number 13. The station was earlier called Monmouth Beach South before two nearby stations, Galilee and Low Moor, were re-named, eliminating reference to Monmouth Beach in their designations.

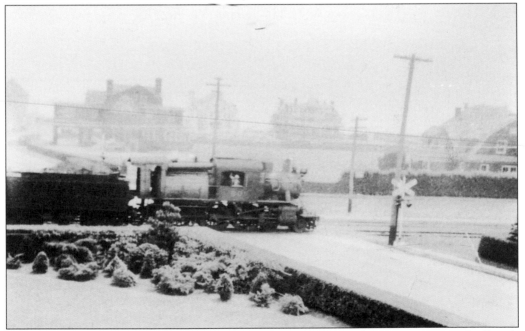

The Central Railroad of New Jersey camelback locomotive number 901 is seen at the Beach Road crossing *c.* 1940. The engine was so named for its positioning of the cab over the center of the boiler in the manner of a camel's hump. The house in the background still stands at the southwest corner with Ocean Avenue.

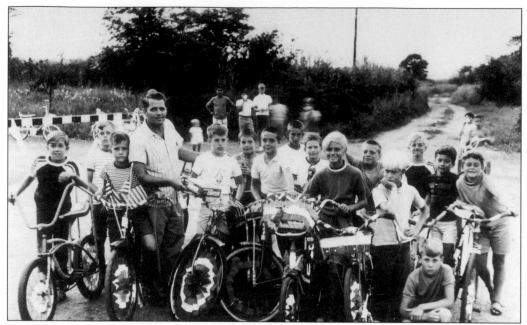

John Gannon, cub master, is seen with Cub Scout participants in a July 26, 1968, bicycle race. The group has gathered for a post-event party at Gannon's Columbus Drive home. Unpaved, unbuilt-upon Elizabeth Place is in the distance. The boys to Gannon's right are Mark Greene, Roderick Petschauer, and John Gannon III. Those to his left are James Brower, Michael Delahanty, Garrett Mihm, Scott Hindley, Gregory Oakes, Daniel Hennessey, Clifford Sommers, David Rombey, Christopher Greene, Mark Anthony (kneeling), Timothy Toohey, and Kevin Toohey.

The Halloween parade is a time-honored Monmouth Beach tradition. Prizes were awarded for students' costumes. The Gannon family made a big effort to win with this 1970s entry. Ronald Gannon is attired in a Styrofoam replica of the Channel Club Tower and is seen in front of the portable classrooms at the elementary school. The rumor that he cast his neighboring marchers in a shadow of darkness is untrue.

Albert S. Benoist, right, recalls that he and friend Wyman Delacorte were "just having a party" in their Indian costumes when a *Times* photographer captured this image *c*. 1927. It was previously published in the *New York Times* Sunday rotogravure section. Delacorte went on to create a substantial career for himself in Dell Publishing (the company name was derived from his surname).

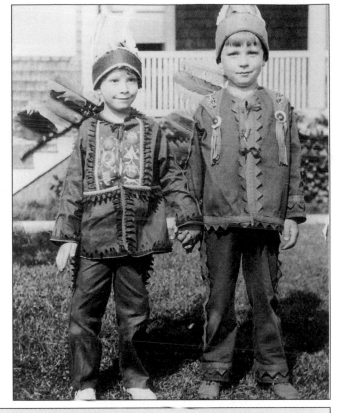

A Long Branch hook and ladder truck is engaged in high aerial activities at the July 4, 1956, 50th anniversary celebration . The scene is Griffin Street; the 1909 school is at left and the later site of the park is on the right.

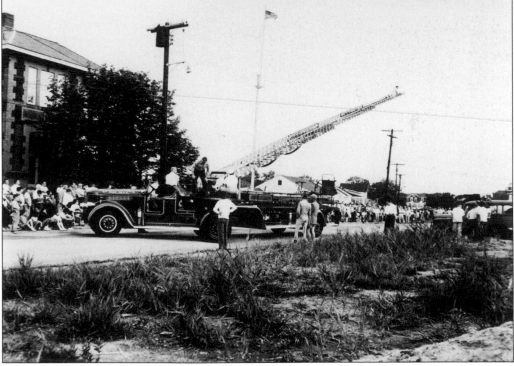

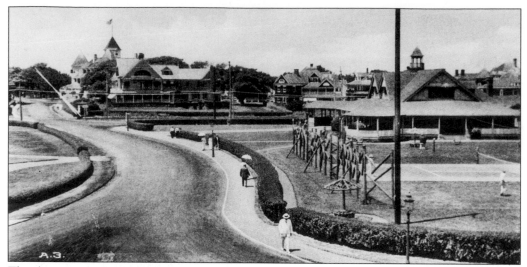

The three prominent buildings embraced in this westward view from the baths are the casino (right and p. 28), 13 Beach Road (p. 36), and the Monmouth Beach Inn (towering over the latter house and on p. 27). The casino's porch that wrapped around the side on the east, as above, or on the west after relocation is indicated on a plot plan for its present location. However, it is unknown if removal was before or after the move. Monmouth Beach was laid out with curved street intersections, making it one of the few towns in America where surveying monumentation is not at street intersections, requiring measurements to be made from interior monuments. (Collection of Michael Steinhorn.)

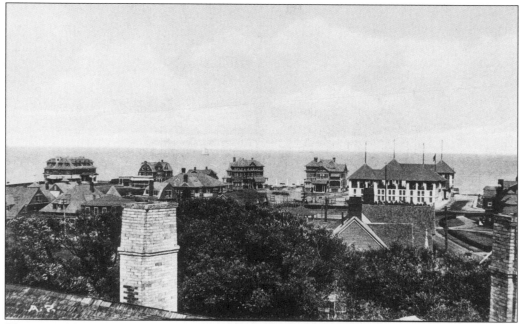

The eastward view from the Monmouth Beach Inn tower focuses on the allied baths building. Adjacent to the north, or left, are waterfront houses removed well prior to those south of the baths. The two images are part of a long series of attractive Albertype postcards published by the inn and baths (c. 1915?) that depict the buildings, including interiors and their surroundings. (Collection of Michael Steinhorn.)

A police kiosk stood at the corner of Beach Road and Ocean Avenue from *c.* late 1920s to an unspecified date. The kiosk, "in storage" for many years, was recovered, restored, and remounted on the northwest corner of Monmouth Beach in March 1998 by the Monmouth Beach Business Association.

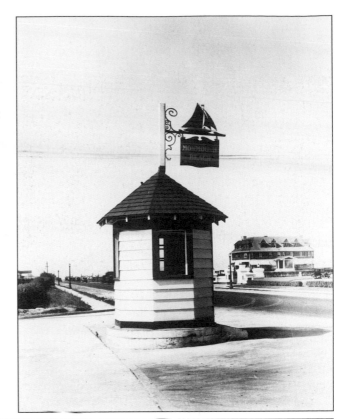

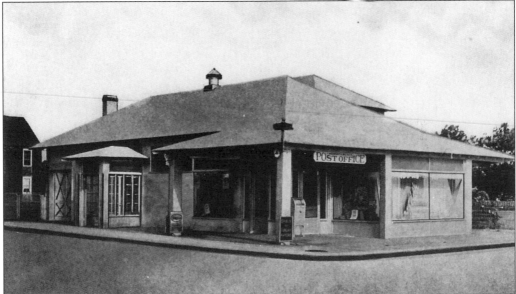

The Monmouth Beach Post Office opened in 1924. John A. Wheeler was the first postmaster, keeping the office in his general store at Beach Road and Riverdale Avenue, publishing this postcard in the 1930s. An earlier post office existing from 1872 to 1875 was discontinued, with mail service then obtained from Atlanticville, later North Long Branch. The Monmouth Beach Mart was built around the store, rendering the old image unrecognizable.

Monmouth Cold Storage Company was founded *c.* 1910 by A.O. Johnson, who during work for Railway Express observed how large fish catches could depress the market. His fish freezer, located on Railroad Avenue south of Valentine Street, aimed to protect fishermen against falling prices. The business, having changed in later years to accommodate the storage of shrimp obtained from the Fulton Fish Market in New York, was plagued by a series of highjackings in the 1970s and closed *c.* 1980. The Monmouth Commons condominiums are on the site now. This image was taken in December 1958. (The Dorn's Collection.)

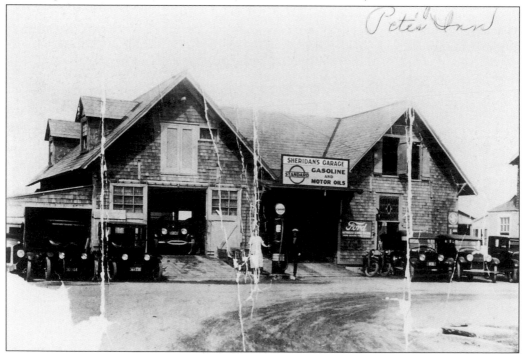

Sheridan's Garage at Willow Road and Robbins Street gives evidence of its origin as a stable in this *c.* 1920s image. The place was occupied by a succession of bars—the only ones in Monmouth Beach—including Pete's Inn, Smith's Tavern, and, now, Boyle's Tavern.

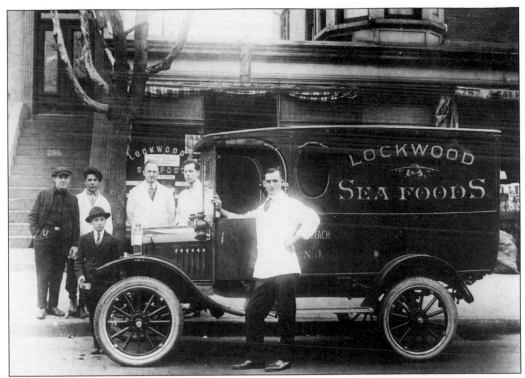

Lockwood Sea Foods (p. 16) served a New York City store from Monmouth Beach. The subjects and location of this c. 1915 photograph are unknown.

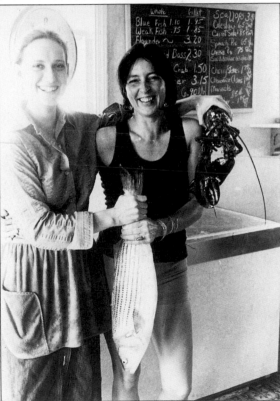

Two young women opened a restaurant in the former Lockwood store, aiming to present a touch of Brittany in Monmouth Beach. Linda Selick-Anagnostakis (left) had a teaching background, while Leslie Lyles had acted prior to raising three children. Their props in September 1977 were a striped bass and a lobster. The business was not nearly as long-lived as a lobster that avoids capture.

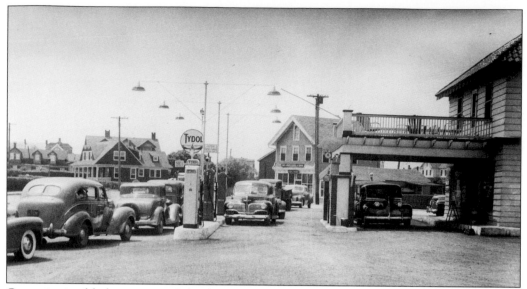

Gas rationing likely occasioned this line in 1943 at John's Tydol Service at the foot of Ocean Avenue, just north of the Long Branch border. North Long Branch had a thriving business district nearby and was more built-up then.

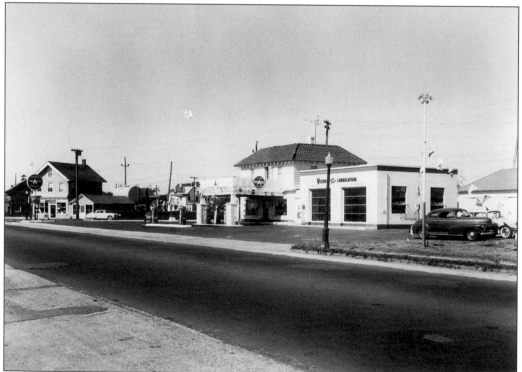

The tile-roofed structure was still in place in 1957 when the place was Andy Tiem's, but a two-bay extension had been built on the north. Ed Wade took over in 1960. The older structure at left is now gone, while the later addition to the station was expanded. The tank at left, no longer standing, served the railroad, which had a storage area behind the gas station. (The Dorn's Collection.)

Five

Sea Bright
Transportation

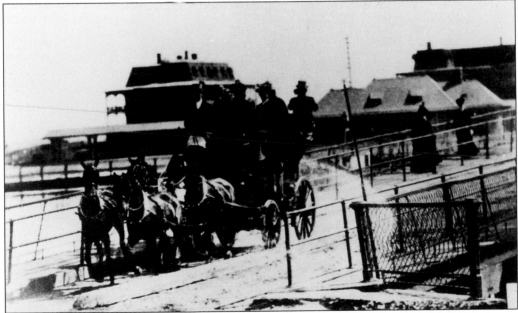

The 1870 bridging of Sea Bright and Rumson was vital to the development of the latter. Sea Bright had a rail connection, which was initially a short run from the steamer dock at nearby Sandy Hook and from 1892 a longer run from Atlantic Highlands, and thriving land connections, such as this c. 1900 coach. The Sea Bright railroad station and the Shippen home are in the background.

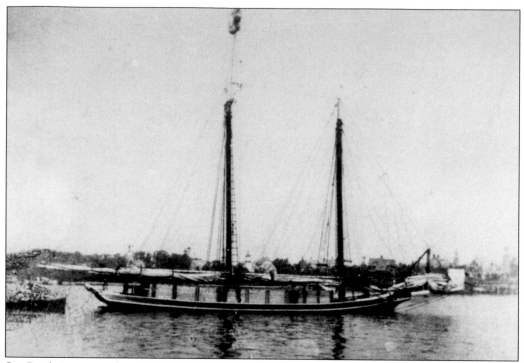

Sea Bright's principal water transport was the steamer, but sailing vessels provided freight service into the 20th century for heavy, bulky, lower-valued cargo, such as building materials, coal, and fertilizer. This *c.* 1910 example is unidentified. (Collection of Peter Thompson.)

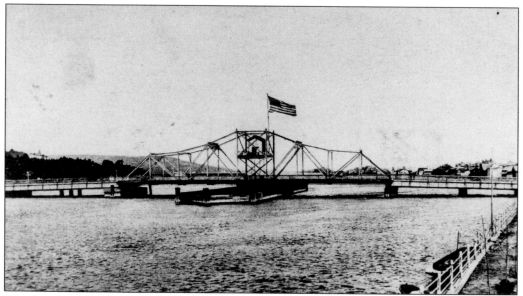

The fourth of the Sea Bright-Rumson bridges, which opened in 1901, is seen on a *c.* 1908 postcard. This bridge, which had a swinging span, served until replaced in 1952. This view is to the north. (Collection of Michael Steinhorn.)

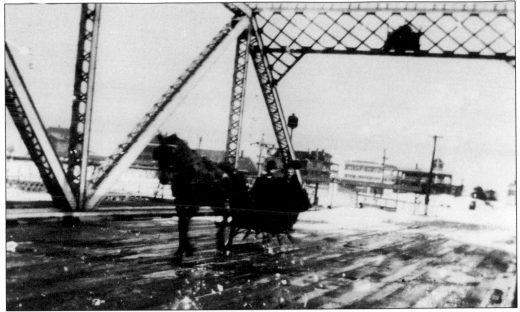

This c. 1910 close-up view of Peter Poppinga crossing the Sea Bright-Rumson bridge gives a good glimpse of the steel frame. The Sea Bright Beach Club and the Shippen house are in the background. (Collection of Peter Thompson.)

The fifth and present Sea Bright-Rumson bridge was completed in 1951, located about 125 feet north of the span pictured at top. Freeholder Joseph C. Irwin is seen during construction in 1950. He served two terms each on the Red Bank council and in the New Jersey Assembly in the 1930s, and ran for the New Jersey Board of Chosen Freeholders in 1938, beginning a tenure lasting through 1974. Irwin, who became known as "Mr. Monmouth County" and presided over the period of the county's greatest growth, died in 1987 at age 83. (The Dorn's Collection.)

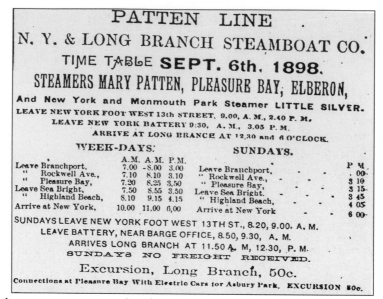

PATTEN LINE

N. Y. & LONG BRANCH STEAMBOAT CO.

TIME TABLE **SEPT. 6th. 1898.**

STEAMERS MARY PATTEN, PLEASURE BAY; ELBERON,

And New York and Monmouth Park Steamer **LITTLE SILVER.**

LEAVE NEW YORK FOOT WEST 13th STREET, 9.00, A. M., 2.40 P. M.

LEAVE NEW YORK BATTERY 9:30, A. M., 3.05 P. M.

ARRIVE AT LONG BRANCH AT 12.30 and 6 O'CLOCK.

WEEK-DAYS.				**SUNDAYS.**				
	A.M.	A.M.	P.M.					P M
Leave Branchport,	7.00	8.00	3.00	Leave Branchport,	-	-	-	00
" Rockwell Ave.,	7.10	8.10	3.10	" Rockwell Ave.,	-	-	-	3 10
" Pleasure Bay,	7.20	8.25	3.50	" Pleasure Bay,	-	-	-	3 15
Leave Sea Bright,	7.50	8.55	3.50	Leave Sea Bright,	-	-	-	3 45
" Highland Beach,	8.10	9.15	4.15	" Highland Beach,	-	-	-	4 05
Arrive at New York,	10.00	11.00	6.00	Arrive at New York	-	-	-	6 00

SUNDAYS LEAVE NEW YORK FOOT WEST 13TH ST., 8.20, 9.00, A. M.

LEAVE BATTERY, NEAR BARGE OFFICE, 8.50, 9.30, A. M.

ARRIVES LONG BRANCH AT 11.50 A. M, 12.30, P. M.

SUNDAYS NO FREIGHT RECEIVED.

Excursion, Long Branch, 50c.

Connections at Pleasure Bay With Electric Cars for Asbury Park. EXCURSION 50c.

Some claim that a steamer ran on the Shrewsbury as early as 1819, but the river was irregularly served in the post-Civil War shore boom as steamer-rail connections along the Atlantic dominated Long Branch area traffic. River steamers concentrated on the Navesink run. Early Shrewsbury River vessels included the *Shrewsbury* and the *Edwin Lewis*. Thomas Patten organized the Seabright and Pleasure Bay Steamboat Company in 1893, building the *Mary Patten*, expecting to make the New York-Sea Bright run in 105 minutes. This 1898 timetable advertisement shows a longer time, since the trip was lengthened by the Highland Beach stop.

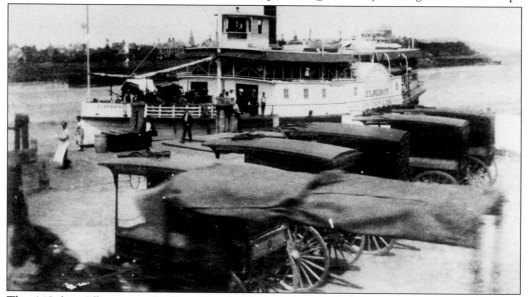

The 143-foot *Elberon* was built at Nyack, New York, in 1888 for the Merchants Steamboat Company for the Shrewsbury River run to Branchport, Long Branch. That company sold the boat to the Seabright and Pleasure Bay Steamboat Company in 1892 to avoid competition, agreeing that the former would run the Navesink River boats and the latter the Shrewsbury River steamers. The vessel, seen *c.* 1900 at Sea Bright, was sold in bankruptcy in 1919. (Collection of Peter Thompson.)

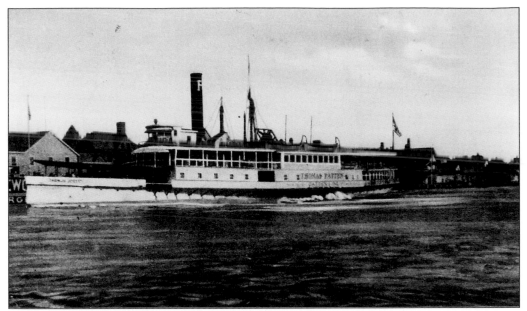

The 201-foot *Thomas Patten*, built in Newburgh, New York, was the largest of the river steamers and the first steel-hulled vessel on the Shrewsbury. Seen on a *c.* 1907 postcard, the boat was sold in 1919 to Maryland interests. It was renamed the *Governor Harrington* and served as a Chesapeake Bay ferry after encountering considerable difficulty leaving New Jersey waters.

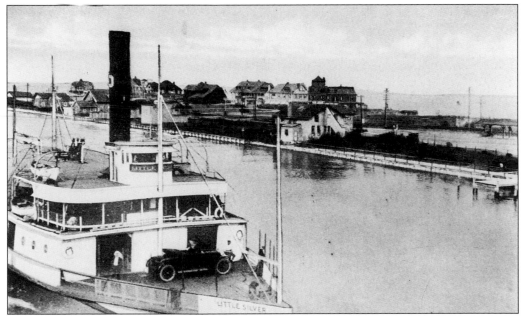

The 159-foot *Little Silver*, built in Nyack, New York, began running in 1894 in opposition to the Patten Line, engaging in a rate war for two seasons until Thomas Patten gained majority control of his competitor. The vessel on this *c.* 1918 postcard is seen carrying a harbinger of the end of steam traffic, an automobile. The view is approaching the Sea Bright-Rumson bridge. The *Little Silver* continued in service until 1932.

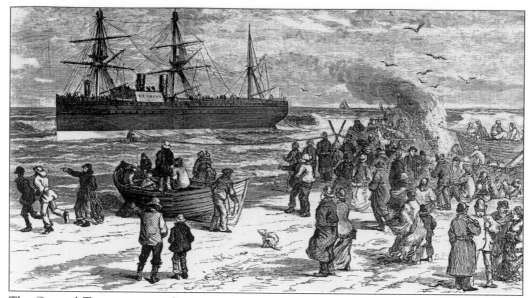

The General Transportation Company's steamship *L'Amerique* ran aground in a storm off Sea Bright on January 7, 1877. Three of eleven crewmen were drowned when the craft capsized. Passengers, remaining crewmen, and cargo were safely removed, the latter in a lengthy process as the ship remained stranded for weeks. Large crowds were attracted, including a *Harpers Weekly* artist. Many efforts to remove the ship were made prior to the Coast Wrecking Company's pulling it off the beach to New York on April 10. This is a Moss Archives reprint of an engraving first published on January 27, 1877.

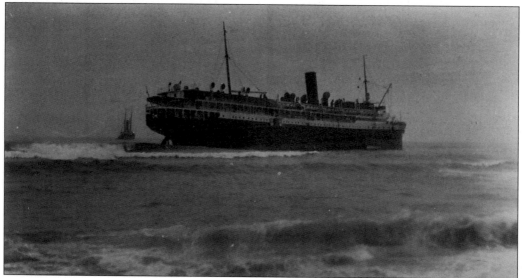

The Clyde Line steamer *Mohawk* collided in a dense fog with the Old Dominion Line liner *Jefferson* on May 19, 1928. The Florida-bound vessel with 37 passengers and a crew of 125, incurred a hole below the waterline, causing Capt. John W. MacKenzie to beach the ship near Normandie. Passengers and cargo were removed, with the *Mohawk* pulled off the sand bar on May 21. The *Mohawk* sailed and collided again; in January 1935 she sank 4 miles off Sea Girt, New Jersey, with the loss of 30 lives, including that of Capt. Joseph E. Wood. The ship went down in the main shipping lane after striking the *Talisman*, which escaped undamaged.

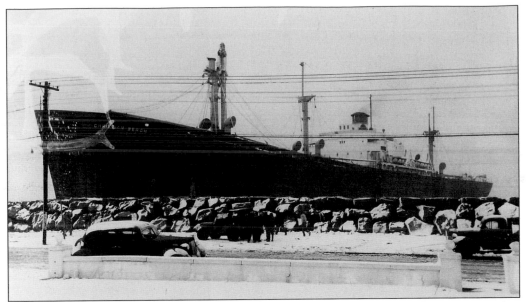

The 7,126-ton freighter *Christian Bergh*, a Liberty ship operated by the Albatross Steamship Company and bound for Hoboken from Patras, Greece, was driven aground by a northeast wind in zero visibility on March 18, 1949. The ship was so close to the Sea Bright shore that crewmen were able to climb down for coffee with spectators of the salvage effort. A tug pulled the ship from shore after 12 hours; the crew was uninjured. (The Dorn's Collection.)

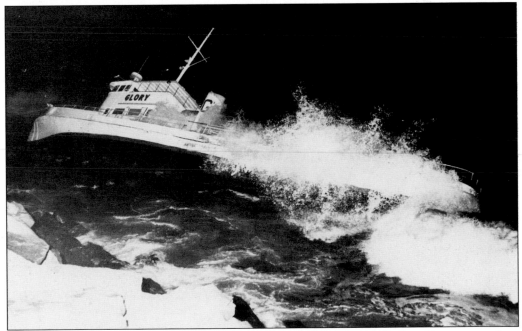

The 105-foot party fishing vessel *Glory*, sailing out of Sheepshead Bay, Brooklyn, incurred an inglorious crash on the rocks at Normandie after running aground in the early morning of June 16, 1975. The ship abandoned a nighttime fishing trip due to heavy seas and limited visibility that proved even rougher and more constricted than expected. Thirteen on board were rescued off the sea wall.

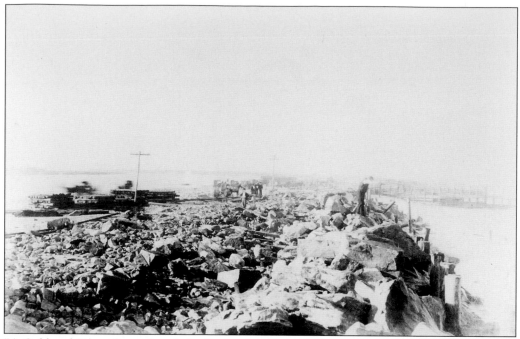

"A Cold and Fierce Storm" read the *Register* headline of September 11, 1889, over an account of a storm that did more damage at the shore than any other in memory of old mariners. Wind and waves moved around the bluff of sand and rocks that stood aside the railroad, as observed in this picture of September 10. A shallow inlet between ocean and river was cut below Highland Beach, but it was closed in about two weeks. (Special Collections and Archives, Rutgers University Libraries.)

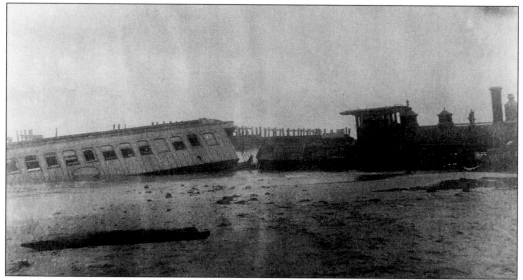

Part of the railroad was washed away, passenger cars were overturned and badly damaged, and for long stretches the track was covered with sand with depths of 2 to 5 feet. Cottagers left early for their city residences, cutting short the season at the shore and impacting local business. This photograph, long believed to depict Sea Bright, was undated until the wreck was spotted in the dated photograph at top.

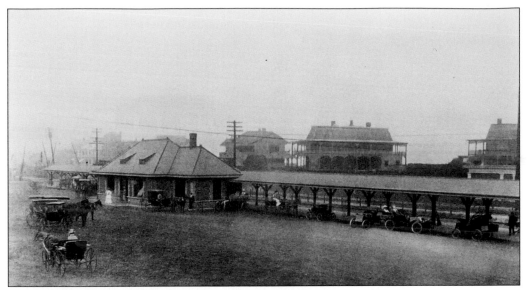

The Sea Bright railroad station, located on Ocean Avenue in front of the present bridge entrance (which is north of the prior bridges), was the principal means of arrival for at least a half-century. New York travelers to Sea Bright came via steamer, initially docking at Sandy Hook, but to Atlantic Highlands, beginning in 1892, continuing by train to Sea Bright along the shore. Unprofitable passenger service was discontinued in 1947; the station was demolished. This is a *c.* 1900 image from Leonard's *Seaside Souvenir.*

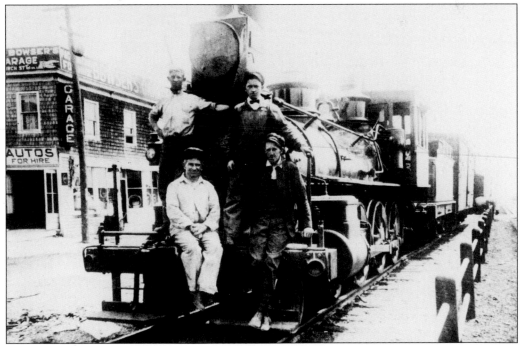

The railroad ran through the center of town at grade, crossing Ocean Avenue around Beach Street. A copy of this image in the Long Branch Library's Durnell Collection dates it to 1914 and identifies those standing as ? Hennessey (left) and Joseph Mahar; seated are Henry Tilton (left) and John Rise.

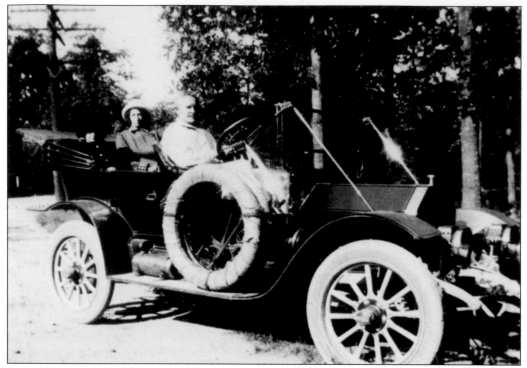

Peter J. Poppinga's Buick was reportedly one of the niftiest cars in town. He is seen on September 14, 1913, with his wife, Cora, and his daughter Louise. (Collection of Peter Thompson.)

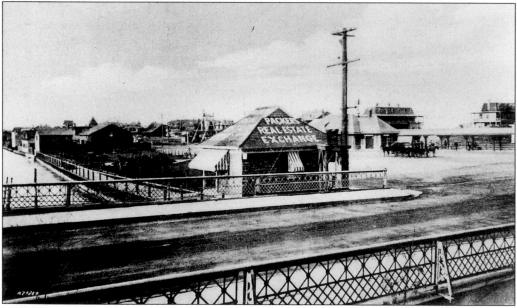

Packer's real estate office, built c. 1905 on the Shrewsbury River shore on the north side of the bridge approach, is viewed with the railroad station in the background. Ollie Packer lived in it in later years, but the building was vacant in the mid-1960s when Harold Solomon's Coast Construction Company demolished it.

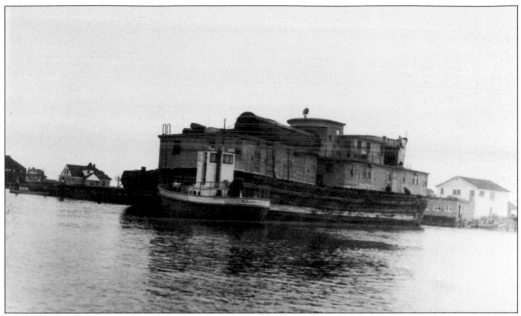

This unusual barge was photographed at Sea Bright on June 16, 1950. Even with the date, no account of its presence could be located. In a related matter, the author would like to know if anyone has a photograph of the barge (which did not stop at shore) that is reported to have recovered a German U-boat off Sea Bright c. 1950. Such a contribution to the documentation of Sea Bright's history would be greatly appreciated.

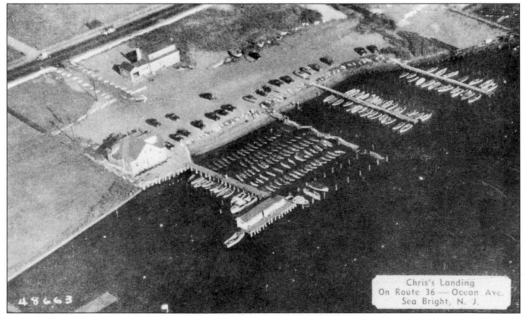

Chris's Landing, run for a while by Joe Stout, an ex-Sea Bright councilman, had a Shrewsbury River rowboat rental operation offering 100 new boats at $1.50 per day at the time of this early 1950s postcard. The facility sold bait and tackle and had a luncheonette. Some seafood lovers believe this was the finest area in the surroundings for gathering soft clams. Condominiums are on the site today.

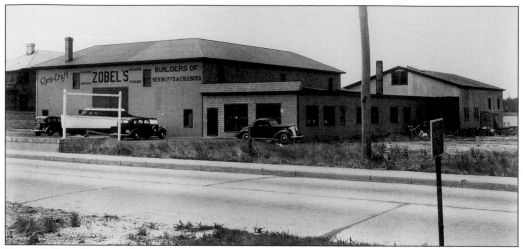

Harry Zobel's boat works, seen *c*. 1940, were located on the Shrewsbury River shore, north of the bridge. The complex, begun in 1929, had three major additions. The boat assembly building is in the rear at right. The Zobel showroom is in front of it. The indoor storage facility, at left, stacked vessels three tiers high. Not visible in the rear is a yard storage and a marine railway. Zobel had an extensive international trade, having shipped to 48 countries. (The Dorn's Collection.)

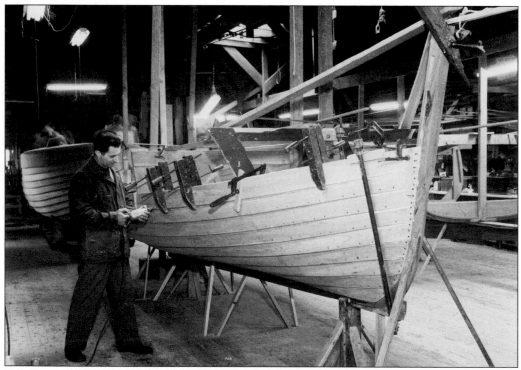

Zobel's specialty was a lap-streaked Jersey sea skiff, typically in the 20–22 foot range but built up to 49 feet. Fred Piach is seen here building one in November 1951. Zobel built small craft for the British government early in World War II and later aided the American war effort. He sold the business in 1957. The premises were destroyed by fire afterwards. Housing is on the site now. (The Dorn's Collection.)

Six

Sea Bright

The Oceanfront

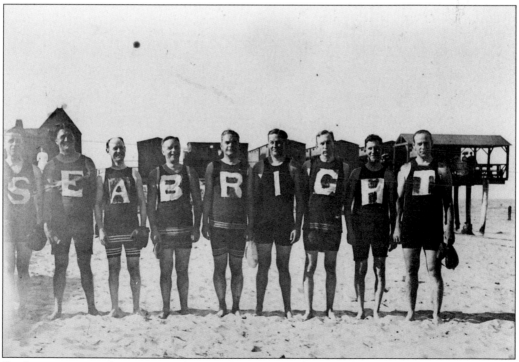

See how many words you can make from S-E-A-B-R-I-G-H-T; feel free to use the white space. Why do some players have baseball gloves (when a glove was a glove and not a basket)? This photograph was taken *c.* 1910. See p. 89 for more information on beach baseball. (Collection of the Atlantic Highlands Historical Society.)

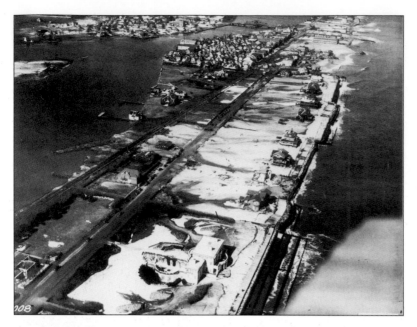

The South Beach area is viewed in April 1927 with the Scrymser house (p. 92) in the foreground. Not a private house now remains in this stretch of beach. The light-colored surface material is presumably sand stirred by a recent storm.

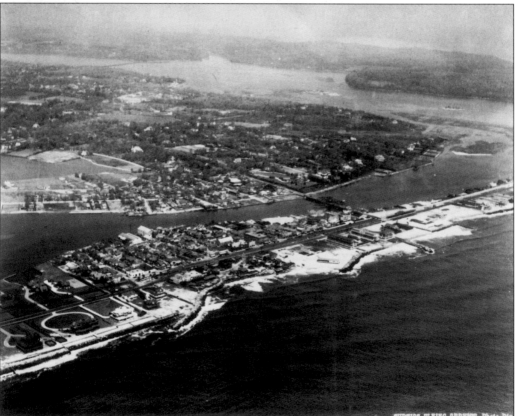

The highest of this volume's several aerials, taken *c.* 1924, shows not only a long stretch of Sea Bright, but the eastern section of Rumson across the river and the hills of Middletown in the background.

Many suspect that government-owned Sandy Hook begins immediately north of the Highlands-Sea Bright Bridge, but Sea Bright continues for about 800 yards above the span. The rails and roadway pictured on the bridge—the site's second—actually crossed, creating a dangerous situation. This bridge was replaced by the present one in 1932, with the newer one now obsolete; a replacement for it is planned. The houses are long gone from the east side of Ocean Avenue. Sandlass's Pavilion was north of the bridge. This image was taken c. 1905.

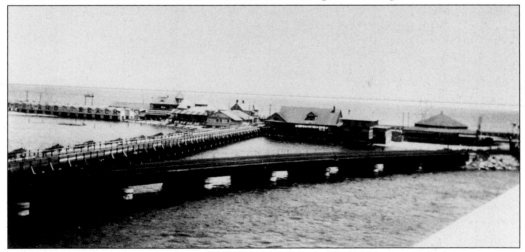

William Sandlass's amusement/recreation area to the north and Ferdinand Fish's real estate development to the south of the bridge were known as Highland Beach. Although the locality name was readily associated with the borough of Highlands across the river, Highland Beach was part of Ocean Township (from which Sea Bright had been formed in 1889) until 1909, when it was absorbed by Sea Bright. The Highland Beach name remained confusing; it was changed by the Sea Bright Borough Council to North Sea Bright in 1939. This image was taken c. 1910.

Bunny Dillon, now Bell, was an outstanding athlete and a strong swimmer. This Red Bank resident and member of Red Bank High School's Class of 1943 earned distinction in 1944 as the only female lifeguard on the ocean, serving at Elliot's Beach Club. Bunny is a 1947 graduate of the Maryland College for Women. She served as a lifeguard while pregnant with four of her five children, was the first president of the Junior League of Monmouth County, and now resides in Geneva, New York. (The Dorn's Collection.)

Bathing beauty Evelyn Leavens handed the author a picture of herself in a proper, one-piece, black bathing suit, claiming that she was in the vanguard of bikini-wearers but that she did not have pictorial evidence. What was he to do, but find one of the guys on the beach who preserved her charming visage. Evelyn is on right with an unidentified companion. She is now one of Monmouth County's finest artists and art teachers.

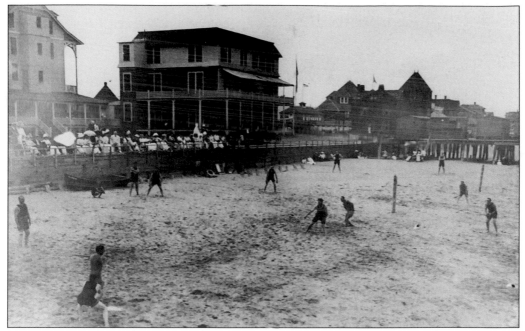

Running on sand must have been quite a challenge for beach baseball players. The spectators in front of the Peninsula House seem rather exposed to foul balls. The image was probably taken c. 1910. The building in center is the North End wing, demolished in 1973. (Collection of the Atlantic Highlands Historical Society.)

Mary Caruso at right and an unknown companion were two of an Atlantic Highlands "gang" visiting Sea Bright beach in the early years of the century.

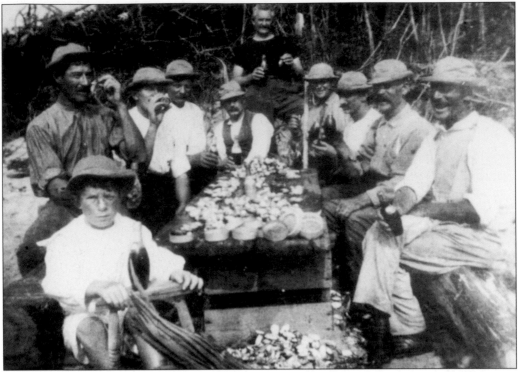

Peter J. Poppinga is presiding over a clambake—a popular shore activity—*c.* 1915. One can not ascertain his beverage, but if it is a Poppinga-stamped bottle, it would be a desirable collectible today. (Collection of Peter Thompson.)

Louise Poppinga (left), the only identified subject here, is in a fishing skiff. The image provides a fine opportunity to view the rear of Church Street. (Collection of Peter Thompson.)

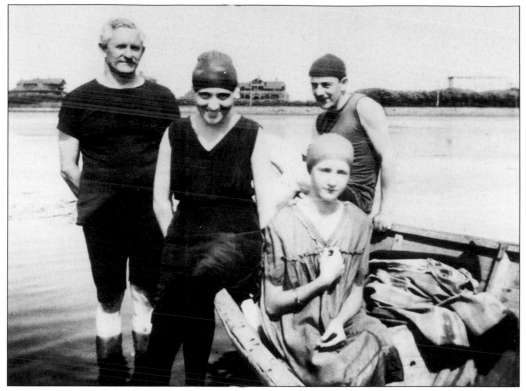

Peter J. Poppinga (left) and his daughter Louise (front) pose casually by the river. Note the c. 1920 swim attire. (Collection of Peter Thompson.)

Hazel Douglas is enjoying a day at the beach in July 1925, well protected from the sun. Her father, Clarence Douglas, appears to be snoozing in the background. Clarence was there with his grandson, Roy Stone, whose nickname at the time was "Pebbles."

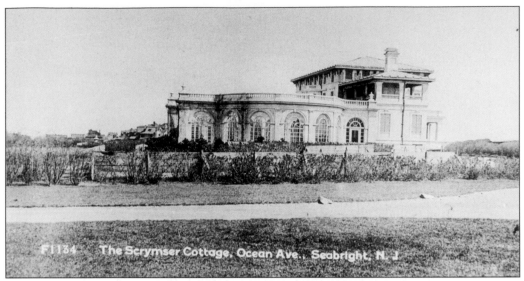

The J.A. Scrymser cottage, an Italian Renaissance Revival design built in 1899 on South Beach, enjoyed stature as one of Sea Bright's finest. The copper-roofed house was clad in white masonry, described during construction as artificial stone. The wing attached to the southwest contained a greenhouse. The place went down at an unspecified date. This image is from a c. 1910 postcard. (Collection of John Rhody.)

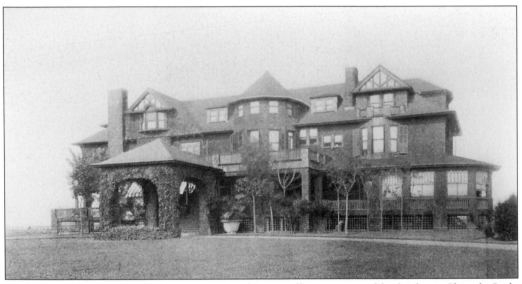

Washington E. Connor's 1897 cottage, named Interwellen, was arguably the finest Shingle Style house in Sea Bright. The 32-room house, later owned by former Secretary of War Lindley M. Garrison, no longer stands. It is seen in a c. 1900 image from W.J. Leonard's *Seaside Souvenir*.

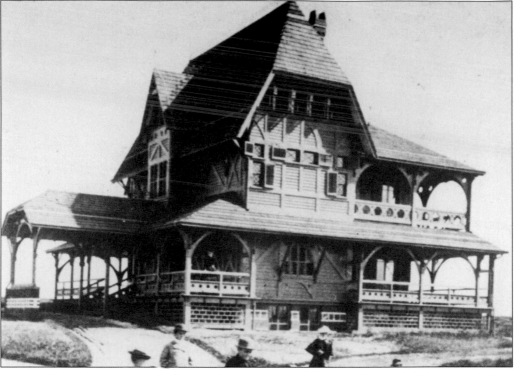

The Connecticut building was one of several moved to the New Jersey shore from the 1876 Centennial Exposition in Philadelphia. A Miss McCurdy moved the house to Sea Bright, having it rebuilt and expanded by distinguished New York architect Robert H. Robertson. The house was purchased by John A. Rutherford and moved on scows down the Navesink River to its present location at 700 Navesink River Road, on the east bank of McClees Creek. (Collection of Long Branch Public Library.)

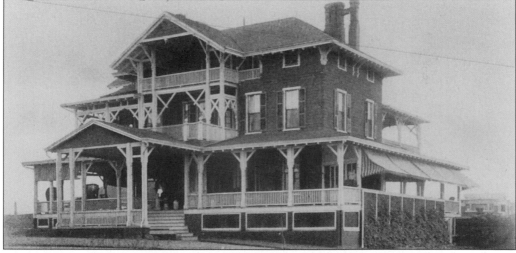

The c. 1880 J. Harson Rhodes house at Low Moor was a hybrid Stick-Shingle Style structure. The owner, a New York dry goods merchant and bank executive, had early warning of the sea's destructiveness, moving the house 40 feet back from the shore in 1884. Its fate is unclear. This is a c. 1900 image from W.J. Leonard's *Seaside Souvenir*.

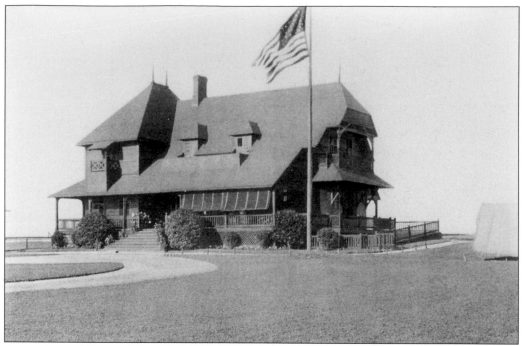

General Lewis Fitzgerald's North Beach Shingle Style house, built *c.* 1880, had an addition erected in 1885. One suspects that it was placed on the north, or left, and that the house may have had Stick Style origins. Researching disappeared houses with little remaining evidence is not the historian's most satisfying pursuit. This *c.* 1900 image is from W.J. Leonard's *Seaside Souvenir*.

Jean Solomon Fulton and Frank Torrey are seen in their refreshment stand at the north end of the borough's public beach in the late 1940s. Notice the advertising signs, attractive collectibles today. The Breyer's maid was a pretty miss.

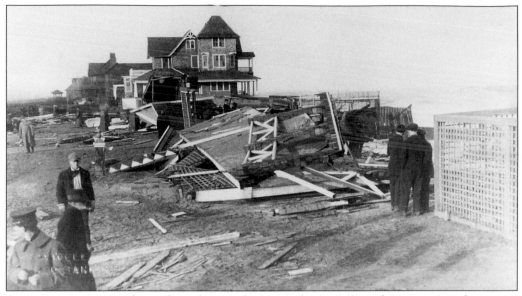

Successive storms on the nights of December 25 and 26, 1913, and January 3 and 4, 1914, battered the coast—particularly Sea Bright—with an unprecedented destructiveness. The earlier storm washed away bulkheads and undermined buildings, such as the Octagon Hotel, increasing their vulnerability to the later one. The Octagon was a total loss. Some shorefront homeowners moved their houses back after the first storm, perhaps protecting themselves from the destructiveness that washed away several houses in January. Pound fisheries were totally destroyed. An extensive photographic record exists; many sites, including the one in this Foxwell image, are unidentified.

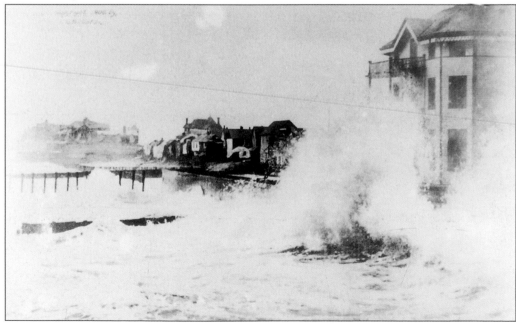

Rough waves hitting the Octagon Hotel were photographed from the pier by George B. Minton on February 23, 1901. He copyrighted the picture for postcard publication five years later during the postcard boom.

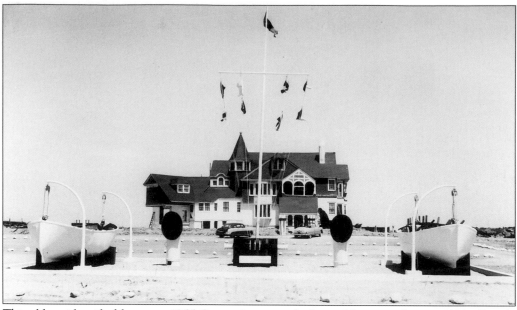

This old, unidentified house at 1355 Ocean Avenue, which would seem to be a c. 1880s Shingle Style-Queen Anne design, is thought to have been converted to apartments by Stephen O'Connor in the 1950s. The Trade Winds Beach Club is in the area now. (The Dorn's Collection.)

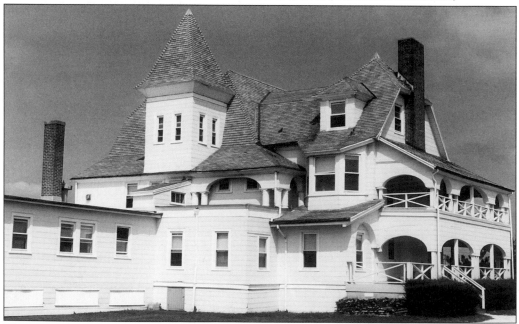

This image of the less-appealing west elevation of St. Peter's Villa at 1530 Ocean Avenue reveals some of the alterations made for the building's adaptation as a vacation home for Jesuit priests. The house, now owned by St. Peter's College in Jersey City, was built in the winter of 1879–80 for Alfred F. Carpenter, and designed by Gambrill and Ficken. The work is likely Ficken's, as the brief partnership was late in Charles Dexter Gambrill's career and Henry Edwards Ficken had other Sea Bright commissions. The house was probably a Stick Style design, but original features are disguised by modifications, including shingle cladding.

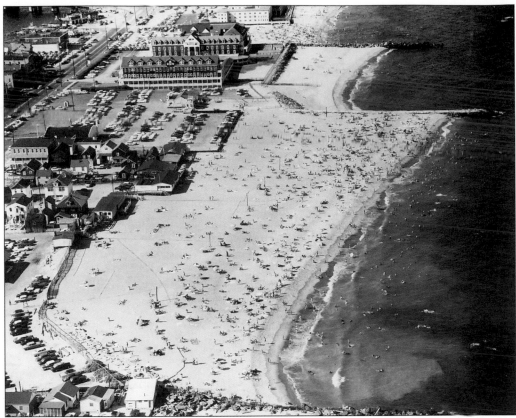

A glimpse of the Sea Bright Beach Club (top), the Peninsula Hotel (below it), and a wide, ample beach are depicted c. 1955. (The Dorn's Collection.)

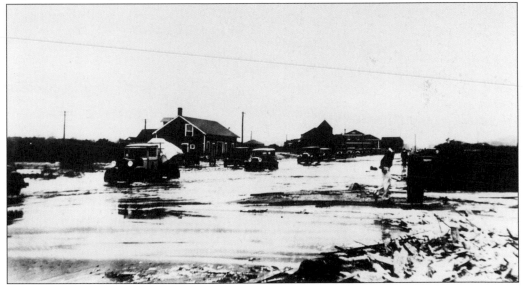

This flooded Ocean Avenue scene is believed to have existed during the summer of 1932. Ocean Avenue still floods, but this problem is mitigated by the existence of the substantial sea wall.

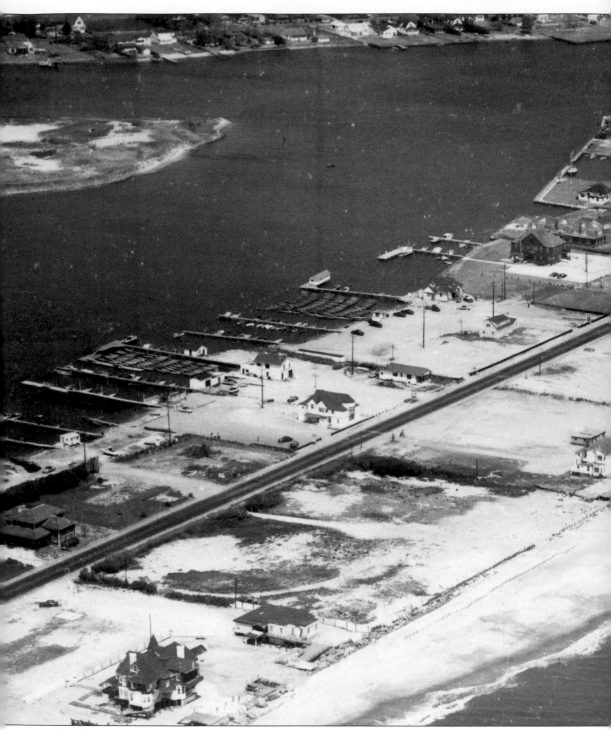

South Beach in the mid-1950s still had several oceanfront houses; many would be converted to clubs or restaurants prior to replacement in the construction boom of condominiums and club structures that began *c*. 1970. The view is looking northwest; Rumson is at top. Chris' Landing

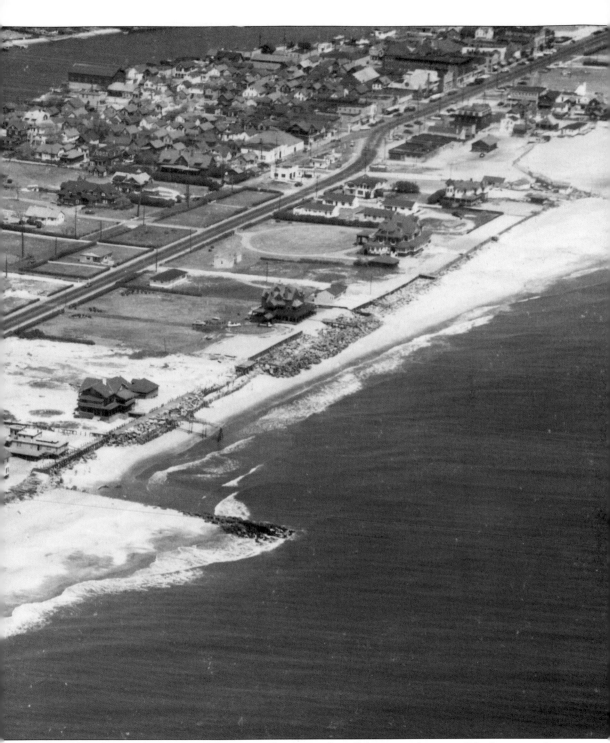

(p. 83) is the northernmost of the two collections of small boats on the river. The house at the lower left (p. 96) is in the vicinity of the Trade Winds Beach Club. The "V" in the road—Ocean Avenue, at right—marks the crossing of the railroad and pavement. (The Dorn's Collection.)

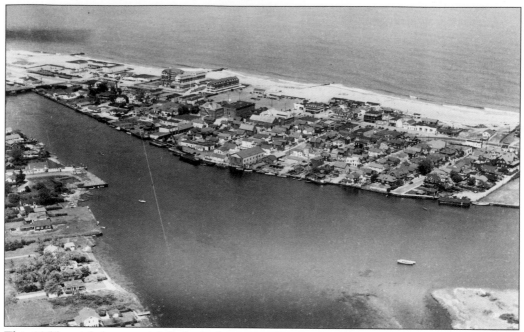

This 1955 aerial shows a tightly built downtown Sea Bright. The Sea Bright Beach Club is at the top left. Ocean Avenue is the street at top; the business district is along its stem at right. The school, the 2 1/2-story, hipped-roof square structure below the south wing of the Peninsula Hotel, provides a focal point for viewers familiar with the west side of Ocean Avenue. (The Dorn's Collection.)

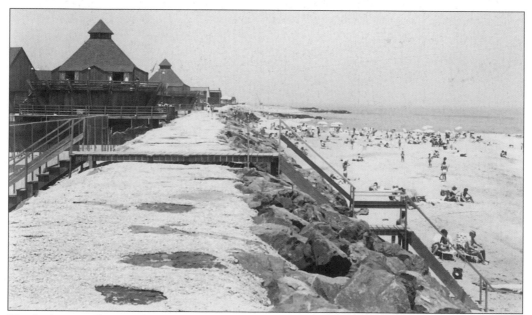

The high sea wall not only contains the ocean, but shields the beach from the eyes of passers-by. This Tova Navarra photograph looks north at the Trade Winds complex. The photographer saw the fragility of the narrow, often pounded stretch of land, wishing it a long future and hoping that the photograph preserved a moment in time and not the image of a vulnerable shore.

Seven

Sea Bright
Hotels

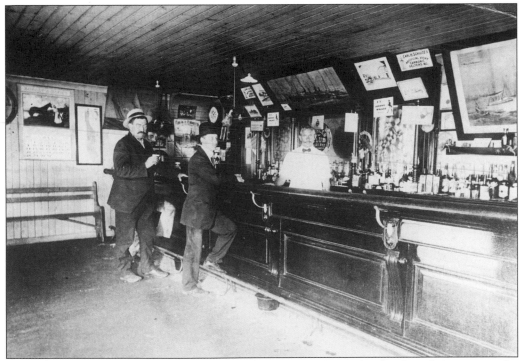

Peter J. Poppinga is seen at the bar of his Riverside Hotel on the south side of South Street near the Shrewsbury River c. 1910. The hotel was the site of the first mass on June 17, 1883, of the newly organized Roman Catholic Church of the Holy Cross, which built an edifice on Ward Avenue in 1885 on the Rumson shore of the Shrewsbury River. (Collection of Peter Thompson.)

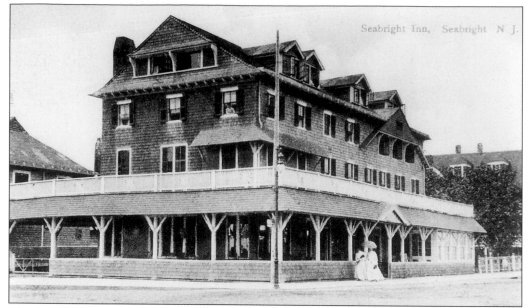

The Sea Bright Inn, one of the town's oldest hotels, was located at the southwest corner of Rumson Road and Ocean Avenue near the entrance to the early Sea Bright-Rumson bridges. A porch on Ocean Avenue connected its 3 1/2- and 2-story sections. Edward Pannaci bought the place in the 1890s, long conducting it as the Pannaci Hotel. It was leased to the Misses Thomas and their brother when destroyed by fire August 22, 1918.

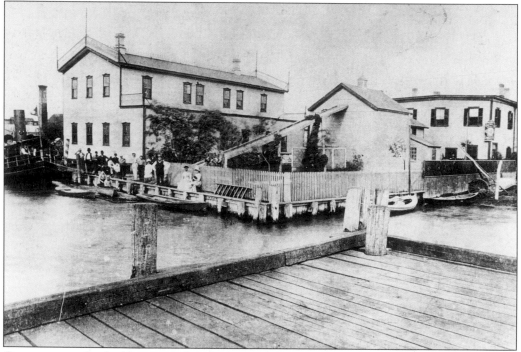

One suspects the building at left is Peter J. Poppinga's Riverside Hotel, while the smaller structure could be its icehouse. Poppinga is known to have built a dock on the river. (Collection of Peter Thompson.)

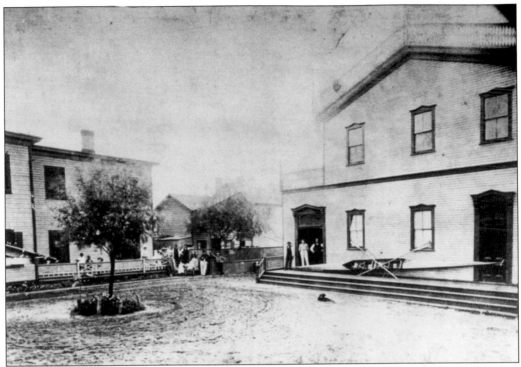

The building at right appears to be the hotel on the bottom of the page opposite. Neighboring buildings included the frame, two-story Hygeia Ice Co., built in 1899. (Collection of Peter Thompson.)

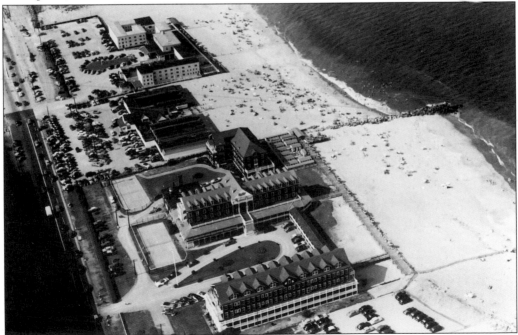

The Peninsula House at bottom and the Sea Bright Beach Club at top flank the Sea Bright Bathing Pavilion in a summer of 1952 aerial. (The Dorn's Collection.)

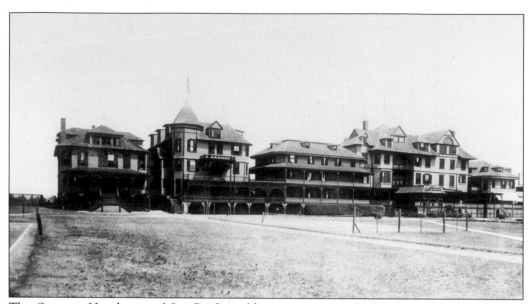

The Octagon Hotel, one of Sea Bright's oldest, was composed of a series of four connected buildings facing the Atlantic Ocean opposite River Street. The house at left was one of two separate members. The building with the tiny dormers is believed to be the original octagonal structure—one can perceive small corner sides—around which the rest was built. Study of the often changed building is difficult due to its disappearance; it was a total loss as a result of the December 1913 and January 1914 storms. (Collection of John Rhody.)

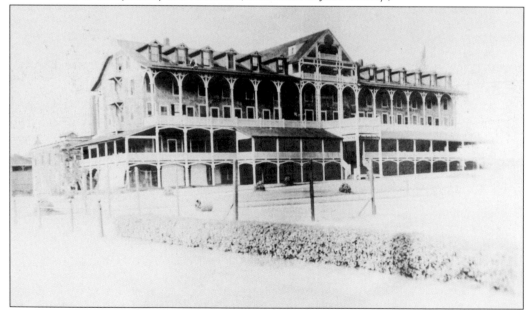

The Peninsula House was an enormous hotel consisting of three principal sections: this, the original building; a smaller, square north wing attached on the northeast corner; and a south wing built in 1917. This much-altered building shows evidence of Stick Style origins. When owner Mifflin Paul moved it across Ocean Avenue to its site opposite Peninsula Street in the winter of 1884–85, it was said to have been the largest building ever moved in Monmouth County. This postcard view of the south facade was made c. 1907. (Collection of John Rhody.)

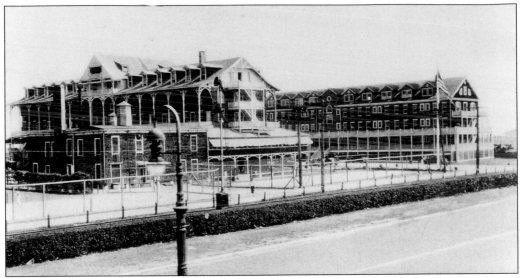

This 1920s view from Ocean Avenue looks southeast; the 1917 wing designed by Charles B. Meyers is at right. The place was taken apart in stages. The north wing was demolished in 1973 and the south wing c. 1968. The main hotel was undergoing renovation when it was destroyed by fire in October 1986.

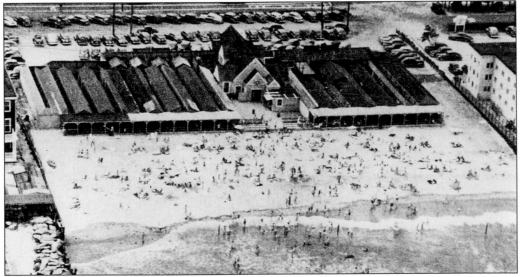

The Sea Bright Bathing Pavilion is seen on a late 1940s postcard. Located between the beach club and the Peninsula House, this facility, owned by Elliot & Shropshire at the time, embraced the former Presbyterian church. The long, narrow structures are lockers. The place is now the Chapel Beach Club.

The Sea Bright Beach Club was organized in 1894 by Rumson summer residents who desired an oceanfront spot for a social bathing club. They bought two existing cottages, which architect George E. Wood remodeled for club use, and opened them for the 1895 season. This c. 1908 postcard appears to show one of the original buildings.

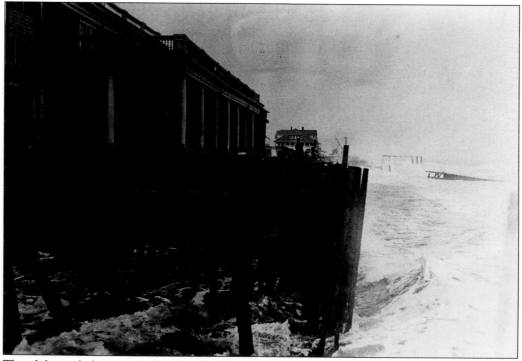

The club regularly expanded its land holdings and facilities over its first quarter century, while battling the storms that ravaged Sea Bright. This is believed to depict the 1913–14 winter storm.

Doris Borden, later Leonard, is seen in 1914 taking a jump in a new pool. The splashing water suggests she followed the prior jumper without a pause.

The Sea Bright Beach Club's 1959 swim team is pictured before a meet with a Monmouth Beach group. They are as follows: (front row) Harry Freeman and Edward Barnes; (second row) Brewster Ellis, Matthew Crane, John Russell, James Beardsley, Barry McDonnell, Garrison King, and John Miller; (third row) James Adamson, John Sinnott, Stephen Simonson, Charles Gross, Philip Greene, Robert Sinnott, David Brewster, and Jay Titus; (fourth row) Charlotte Ellis and Jean Sinnott; (fifth row) Suzanne Van der Leur, Dorothy Beardsley, Sarah Davis, Andrea King, Jill Chamberlain, Patricia Sinnott, Cordelia Crane, and Roberta Pierce; (back row) Jeannie Pascale, Marion Beardsley, Judith Chamberlain, Martha Robinson, Cynthia Russell, and Deborah Davis.

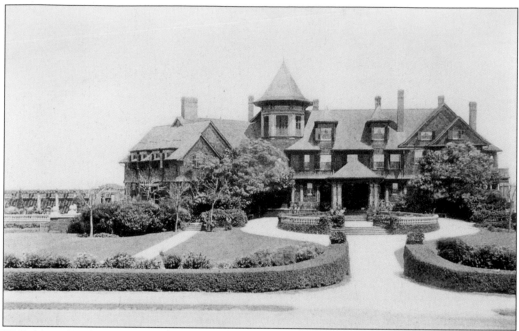

William Nelson Cromwell owned multiple houses, replacing at least one older one on the same site. This may be his large 1897 house; the image is *c.* 1900 from W.J. Leonard's *Seaside Souvenir.*

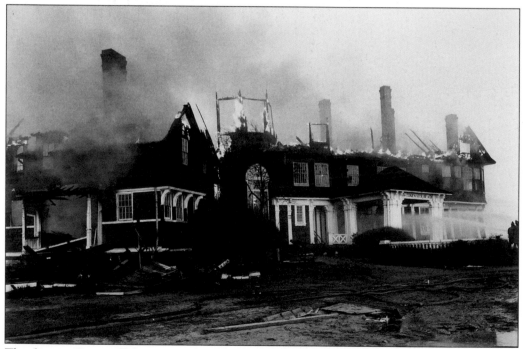

The former Cromwell house was bought by Sea Bright Councilman John Picknally in the late 1940s and converted to the Edgewater Beach Hotel. It was heavily damaged by a storm in November 1953, occasioning its condemnation by the building inspector. The hotel was destroyed by fire on April 30, 1954. (The Dorn's Collection.)

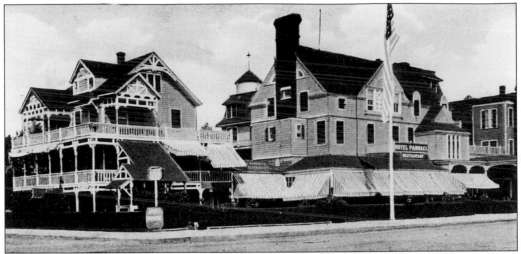

Harmony Hall, built in 1881 by Hilbourne L. Roosevelt, a famed pipe organ builder, was bought in 1887 by Edward Pannaci, who operated it as the Pannaci Hotel. The house at left, part of the establishment, stood longer than the hotel, having been demolished as late as the 1990s.

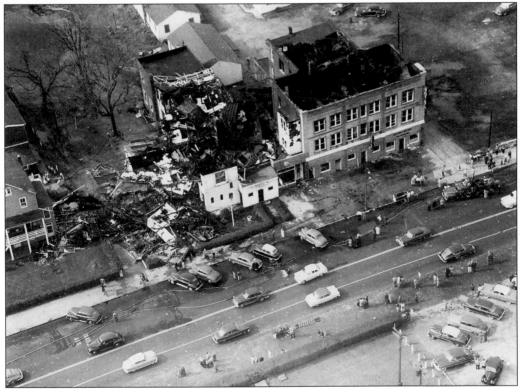

An October 31, 1953, fire destroyed two hotels—the Charles Manor and the Sea Bright Inn (the former Pannaci Hotel)—the Packer Real Estate Agency, and the Sea Bright Post Office. The blaze, which appeared to have started in the boiler room of the Charles Manor, raged for six hours and was controlled by the efforts of about 10 fire companies; aerial trucks from Red Bank and Long Branch were particularly effective. The ruins were doused into the next morning—when this image was made—to prevent the fire from breaking out again. (The Dorn's Collection.)

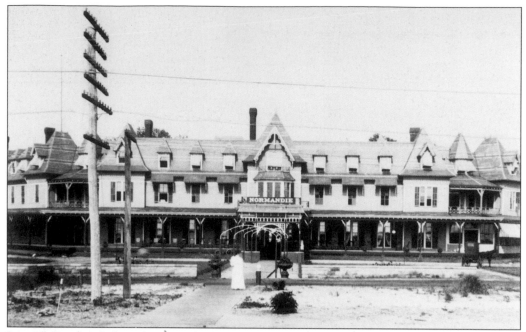

Lemuel Smith is believed to have built the Hotel Bellevue *c.* 1876 on the oceanfront near the Navesink River, selling it to Frederick P. Earle in 1887. Earle renamed it the Normandie-by-the-Sea for a hotel he owned in New York. The place was greatly enlarged, faced both ocean and river, and secured a railroad station *c.* 1883 that was named for the hotel. Normandie also gained use as a locality name. The hotel, vacant for a few seasons, was destroyed by fire in 1916. This image is a *c.* 1910 DeHart & Letson photo postcard. (Collection of John Rhody.)

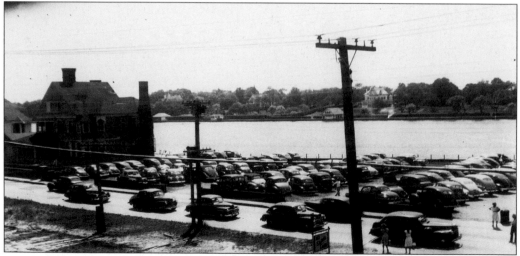

Automobile traffic increased considerably in the post-World War II era, slowing travel and necessitating more space to park cars. This 1946 image looks southwest from Sandlasses (p. 112), 825 Ocean Avenue, across the Shrewsbury River to Rumson, past a still-standing but altered house at left.

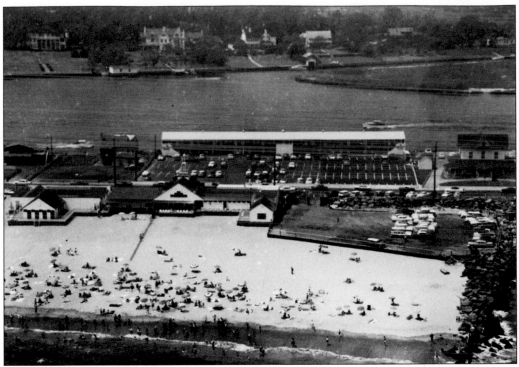

Otto Gillig's Ship Ahoy Motel at 800 Ocean Avenue was one of the area's most modern when it was built c. 1950. Each unit had its own deck over the Shrewsbury River. The amenities that they offered included modern decor, ceramic tile baths, rubber tile floors, and Simmons metal furniture and bedding. The season ran from March 15 through December 15. This image was taken in July 1957. (The Dorn's Collection.)

The Ship Ahoy Motel, having deteriorated from exposure at sits waterfront locale, was demolished in October 1978.

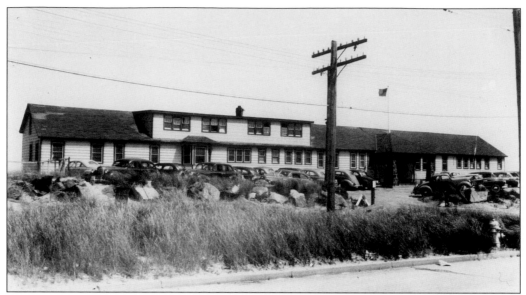

The Sandlass Beach Club, seen in 1946 on North Beach at number 825 Ocean Avenue, is now the site of the Sands Beach Club.

The crew at Sandlasses in August 1947 included office worker Alex Finch (front, second from left), who preserved this image of his co-workers.

Eight

Sea Bright
Downtown

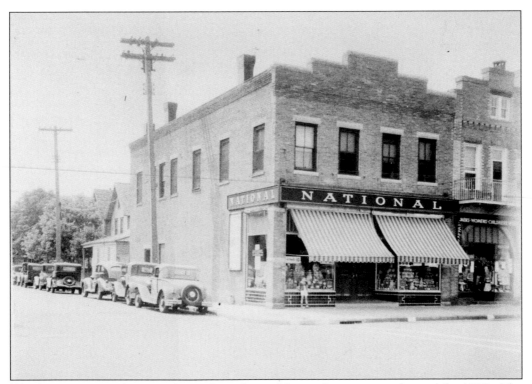

The former Minton drugstore (p. 114) was later a National grocery, seen here in the 1930s. The youthful Harold Solomon, grandson of the owner, is in front. The building, built by grandfather Herman in 1895 and erected by C.V. Shropshire, remained in the family until 1985; it is now occupied by a real estate office.

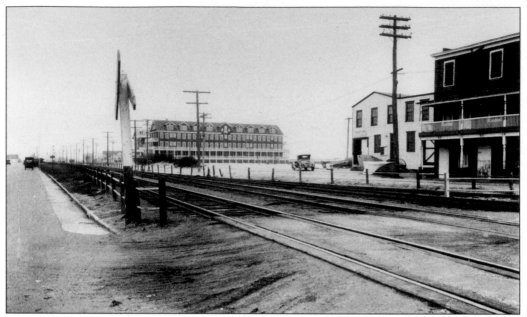

This 1925 image conveys the closeness of the rails to Ocean Avenue and the proximity of the business and hotel sections. The well-placed fisherman's boat and cart in front of the James Lee Fish Market nearly appear to be photographer's props. The south wing of the Peninsula Hotel is north of the market.

George B. Minton's drugstore at the northwest corner of Ocean Avenue and River Street is viewed c. 1910. The open door at right indicates Herman Solomon's tailor shop, while the reflection in the window is that of the Octagon Hotel (p. 104). Leaning on a cane is Jake the Cop, Sea Bright's one-man police force of the time.

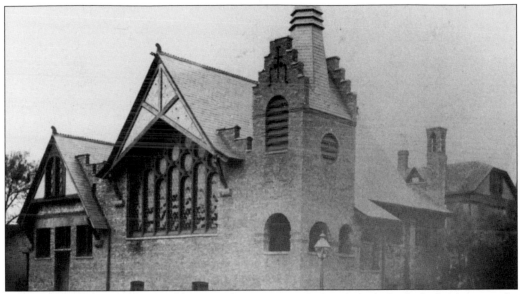

William B. Bigelow designed this Romanesque Revival church with Stick Style elements for the Sea Bright Methodists; it was erected by Long Branch builder A.P. Cubberly in 1889 on the northwest corner of Ocean Avenue and Church Street. The tower contained a porch adjacent to the sanctuary that seated 250, and a Sunday school building was on the left, or west. Bigelow's design was published in the November 9, 1889 *American Architect and Building News.* The church was destroyed by the fire of June 16, 1891, that leveled much of downtown Sea Bright.

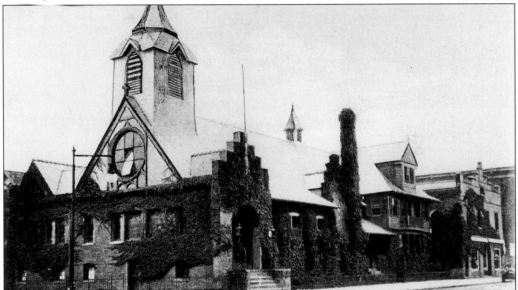

Bigelow and Cubberly collaborated to create a replacement church and parsonage in 1892. Comparison with the picture at top reveals notable differences, especially the relocation of the steeple from the corner to the gable end of the sanctuary roof. The church contains a memorial window to Clinton B. Fisk, a key raiser of funds for reconstruction and a nationally known political figure. The basic appearance today is similar, but the steeple has been rebuilt and the flagpole and small cupola are gone.

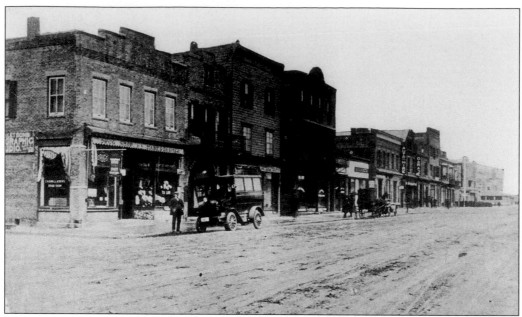

Herman Solomon, a haberdasher with half the corner building, is standing in front of the first Red Bank-Sea Bright bus *c.* 1912. The block north of River Street is largely intact today, but the second and third buildings have an odd frame upper-level front and the fourth one sports a later step gable.

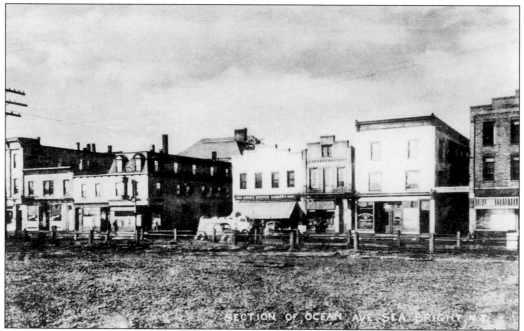

A 1940s postcard provides another view of the corner at top. In addition, the roof of the school (p. 126) is in the background. The other (south) corner of River Street, once home to Levy's Department Store, now houses the Sea Bright Pharmacy. Number 1074, the partially seen building at right, now Angelica's Restaurant, was used by the Peninsula House in the World War II era as a dormitory for waitresses.

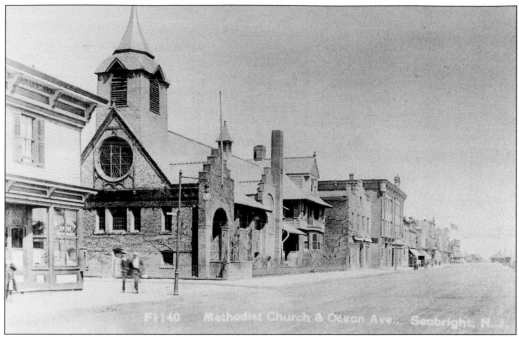

William B. Bigelow also designed the Methodist parsonage, the building with the large dormer in the upper floor that is now an office. The street on the c. 1910 postcard is the west side of Ocean Avenue running north from Church to South Street. (Collection of Michael Steinhorn.)

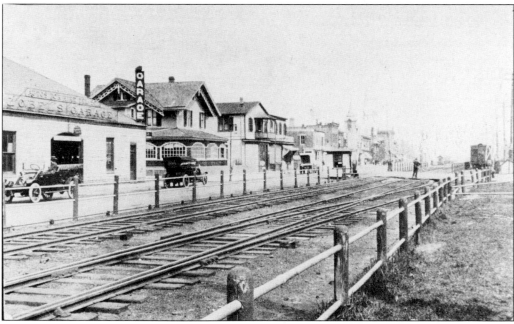

The southern stem of the west side of Ocean Avenue's business district once housed the garage of automobile dealer Zobel, whose showroom was farther up the street. The premises are retail now. Spirits Liquors is in the store space recently occupied by Foodtown. The view is taken from a c. 1918 postcard. (Collection of John Rhody.)

A solitary figure is walking west on South Street *c.* 1910. Is his head down in day's-end weariness or is he keeping his face out of the sun? The elementary school is the tall structure in the background. A garage fronting on River Street is behind the house, while the roof of another garage running the block from South to River is barely visible under the school. (Collection of Peter Thompson.)

Fishermen wheeling their carts *c.* 1910, perhaps on Surf Street, could have come from the icehouse on the river. Fishermen settled the Sea Bright area well before the hotel industry or the summer cottagers in a village called Nauvoo. Many were Swedes. Their quaint beachfront huts were a popular subject for 19th-century artists. Shore fishing activity dwindled by World War II, while the last surf boat (pp. 16 and 17) was reported to be gone in 1953.

The R.H. Macy & Co. 65-by-40-foot storage warehouse on the Shrewsbury River was destroyed by fire on November 8, 1911, along with its contents of delivery wagons and equipment. The blaze, discovered by bulkhead-builder Jesse Howland, who was working on the Rumson shore, threatened other buildings but was confined to the warehouse. (Collection of Peter Thompson.)

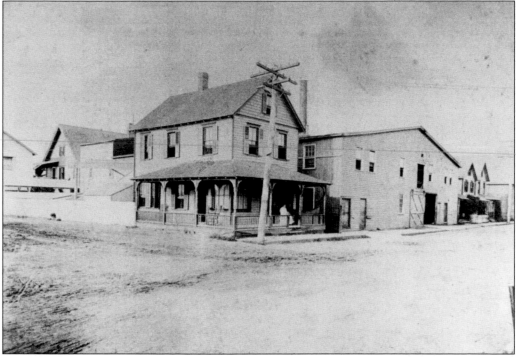

This is probably Peter J. Poppinga's house on the north side of Church Street near the Shrewsbury River. The large frame building to the right appears to be the Hygeia Ice Co. c. 1910. (Collection of Peter Thompson.)

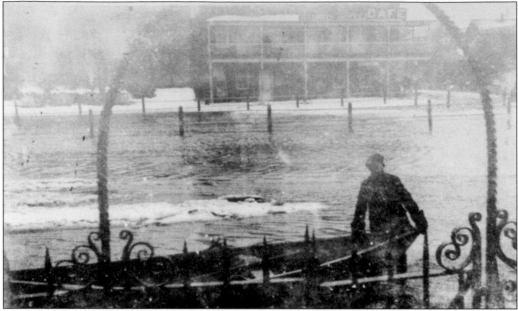

The fence gives an artistic character to this view of an unidentified Sea Bright storm. (Collection of Peter Thompson.)

Clarence Douglas and his part-time working sons, Gerard, Clarence Jr. (Buddy), and Joseph, operated a moving and storage business at 4 Church Street. This truck was likely pride of the fleet *c.* 1930s.

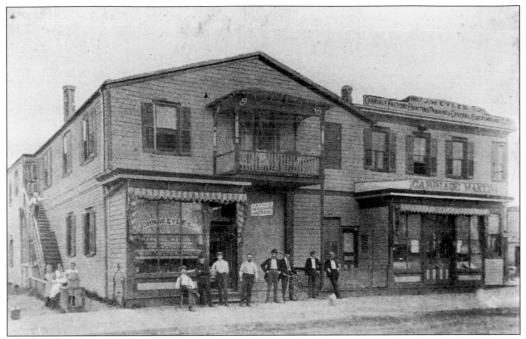

John W. Eyles, carriage maker, also made and repaired harnesses and maintained a storage operation. His business was on the southwest corner of Ocean Avenue and Surf Street. Carriage assembly was conducted in the north building at right, while the building at left was a paint shop. The line included opera busses, wagonettes, depot wagons, runabouts, and buggies. This *c.* 1904 image is from that year's W.A. Norton's *Red Bank Directory*.

Elizabeth Minaldi Oakes, born in 1931, posed in front of the Sea Bright service memorial at her *c.* 1944 elementary school graduation. Her picture creates an opportunity to review the town's World War II military participation and get a glimpse of the Peninsula House in the background.

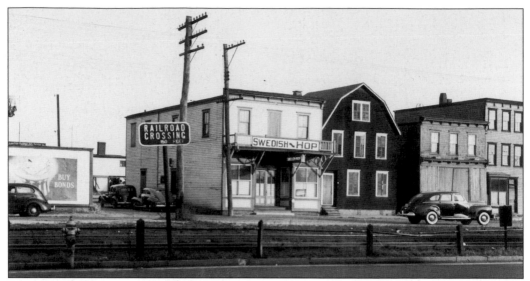

The Swedish Hop was a social-recreational reminder of the town's origins as a Scandinavian fishing village. Its early patrons were Swede fishermen. A bar, My Father's Place (not a reference to the author's father), still stands on the site on the east side of Ocean Avenue, having been extended into the gambrel-roofed building in the center. (The Dorn's Collection.)

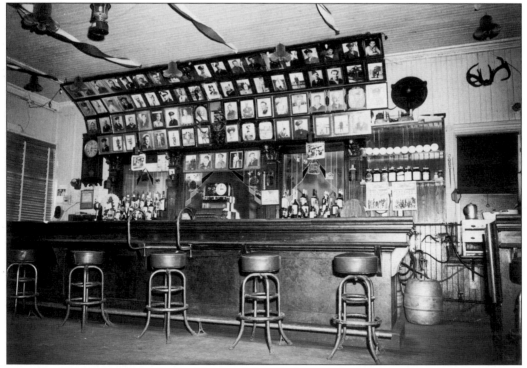

The Swedish Hop was a simple "shot and beer" place. It had an accordionist who played Swedish dance tunes for the regulars. This c. 1943 photograph, closely cropped, was used to make a postcard. The original, showing beer keg, rail, and wall reflection better illustrates a bar, however. The wall photographs depict locals serving in the World War II armed forces. (The Dorn's Collection.)

Jane Clayton secured early business experience in the Sea Bright family firm, Eugene and Company, institutional grocers, and is seen in her office there in 1978. She is best known as a county official, distinguished as the first woman to be elected freeholder in 1976. After serving one term, Jane was elected county clerk in 1979, winning reelection in 1984, 1989, and 1994, and retiring on December 31, 1996. Her accomplishment with the greatest public profile is the establishment of the county clerk's archives, a state-of-the-art facility built within the county library at Manalapan.

Parmly's Tackle Shop at 1154 Ocean Avenue opened c. 1948 when John and Jean Parmly were married. They sold fishing equipment, guns, sporting goods, and clothing. Images of Pendleton shirts stuck in Jean Parmly's mind, which is understandable as some of these durable garments are probably still in use. The store closed in the early 1960s. The site was desired by Foodtown for a parking lot, and it is presently used as such even though Foodtown has departed. This photograph was made c. 1950 for a Dexter postcard. (Collection of John Rhody.)

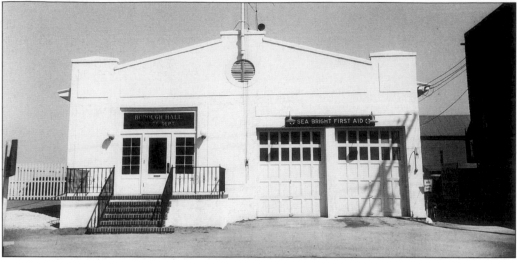

A former fish house was remodeled for use as a borough hall, police station, and first aid building at 1099 East Ocean Avenue. The police, who were initially located in the rear of the building (not visible in this 1950s photograph), occupied the entire north (or left) side after the present borough hall opened in the 1970s (see p. 127). The building is still recognizable today, although its front is clad in brick. (The Dorn's Collection.)

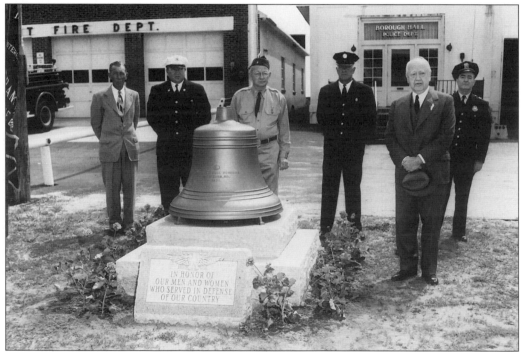

A memorial bell to honor the men and women who served in defense of our country was dedicated on Memorial Day, May 30, 1956, in front of the borough hall. Present were, from left to right, Councilman Kenneth Anderson, Fire Chief Andrew Johnson, Councilman and Ground Observer Corps Lt. Col. Neils Jacobson, Councilman and former Fire Chief John Carlson, Congressman James C. Auchincloss of Rumson, and Police Capt. George Dougherty. (The Dorn's Collection.)

The Sea Bright Fire Department's G.M.C. 500-gallon pumper is seen on Ocean Avenue c. 1951.

James McPeak was an early policeman.

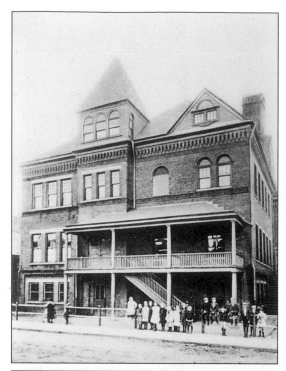

The Romanesque Revival section at right was the first part of the Sea Bright Elementary School, built in 1891. The section at left was added later. This view, from a *c.* 1907 postcard, looks at the south side of River Street. This example is an invitation from James S. McCain to Charles Smith to attend the domestic science class's annual supper for the board of education on April 30, 1909, at 4:30. The building stands vacant, not used as a school since *c.* late 1970s.

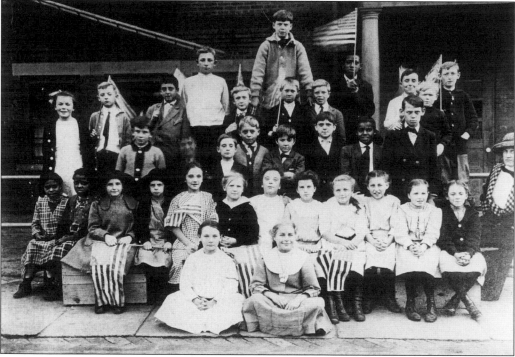

A Sea Bright elementary school class is seen here, perhaps *c.* World War I. Cora Louise Poppinga, later Thompson, can be identified—third from the left in the first row. Her son Peter preserved the picture. The visage of the teacher at right implies a message: "Don't step out of line." Or, perhaps she just did not like having her picture taken.

The Sea Bright Borough Hall is located at the northeast corner of East Church Street and Ocean Avenue. The building had been a beach club close to shore and was slated for demolition. It was moved to its present site in the early 1970s and modified for recreational use before borough offices were added. This image was taken in 1986.

Cecile F. Norton, first elected to the borough council in 1960, was the first woman on the Monmouth County Board of Chosen Freeholders, having been appointed in the 1970s. Present Mayor Charles Rooney Jr., who moved from Jersey City in 1966 after many years as a summer resident, was elected to the council in 1968, becoming mayor in 1988. He is widely known for his spontaneity, candor, and love for his hometown.

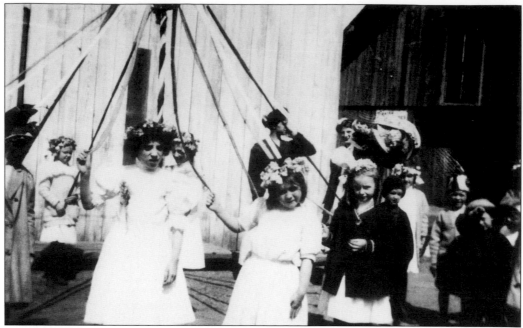

An unidentified May Day celebration in the early 20th century provides a glimpse of period costumes and a form of recreation long passed from the American scene. (Collection of Peter Thompson.)

This vigorous-looking quintet, the 1919–20 Eagles, champions of the local 100-pound league, played upstairs over Bowser's Church Street garage. They are, from left to right, as follows: (seated) Joseph Sheridan and Joe Conk; (standing) Herbert Fowler, Eugene Gardella, and Gerard Douglas (whose niece Elizabeth Oakes lent the picture). Notice that there were no substitutes. One drawback was that there were no breaks for weary athletes; on the other hand, no one complained about inadequate playing time.